LEGENDARY LOCALS

OF

ESTES PARK

COLORADO

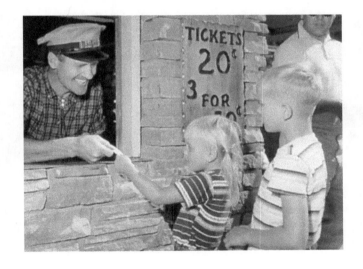

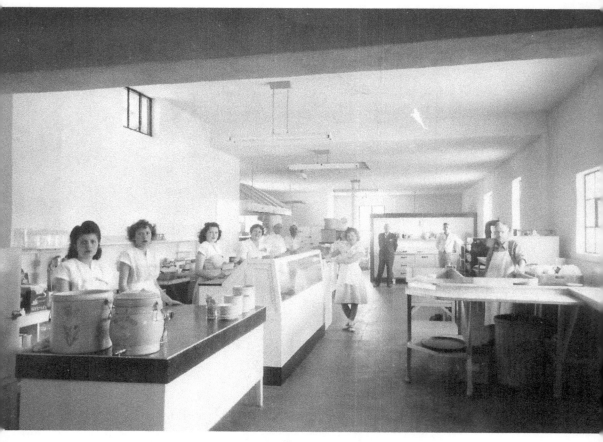

The Kitchen of the Old Plantation Restaurant
C. Warren "Chappy" Chapman and Bob Burgess pose at the rear of the kitchen of the Old Plantation, a popular restaurant for locals and visitors from 1931 to 1992. (Courtesy of Debbie Burgess Richardson.)

Page 1: Phil "Casey" Martin Sells Tickets
Phil "Casey" Martin sells children tickets for his Silver Streak train, a popular attraction for summer visitors that ran in downtown Estes Park from 1947 to 1972. (Courtesy of Estes Park Museum.)

LEGENDARY LOCALS
OF
ESTES PARK
COLORADO

STEVE MITCHELL

Copyright © 2016 by Steve Mitchell
ISBN 978-1-5316-9810-2

Legendary Locals is an imprint of Arcadia Publishing
Charleston, South Carolina

Library of Congress Control Number: 2015943992

For all general information, please contact Arcadia Publishing:
Telephone 843-853-2070
Fax 843-853-0044
E-mail sales@arcadiapublishing.com
For customer service and orders:
Toll-Free 1-888-313-2665

Visit us on the Internet at www.arcadiapublishing.com

Dedication
To those dedicated people who preserve the local history of Estes Park.

On the Front Cover: Clockwise from top left:
Lisa Foster, climber, author, and dedicated mother (courtesy of Lisa Foster; see page 46), Charlie Eagle Plume, Indian activist (courtesy of Estes Park Museum; see page 109), William James and the Elkhorn Lodge (courtesy of Pieter Hondius; see page 14), Wendy Koenig Schuett, Olympian, civil servant, and businesswoman (courtesy of Wendy Koenig Schuett; see page 114), Greig Steiner, artist, dancer, and stage director (courtesy of Greig Steiner; see page 56), "Crazy Ed" Kelsch, town personality (courtesy and copyright of James Frank; see page 113), Bernie Dannels, the "Plaid Mayor" (courtesy of Glenna Dannels; see page 66), George and Phyllis Hurt, concessionaires at Hidden Valley Ski Area (courtesy of Hurt family; see page 39), Paula Steige, bookshop owner (photograph by Heidi Wagner; see page 71).

On the Back Cover: From left to right:
Amy Hamrick and her coffee shop Kind Coffee (photograph by Tony Bielat; see page 79), Abner Sprague, early settler and innkeeper (courtesy of Rocky Mountain National Park Archives; see page 13).

CONTENTS

ACKNOWLEDGMENTS

I am thankful to those who preserve local history, especially local history librarian Lennie Bemiss, who walked into the Estes Park Library in 1972 and asked my aunt, librarian Ruth Deffenbaugh, if she could volunteer. Without Lennie's pioneering local history work, I would not have access to a treasure trove of oral histories and a partial index to the *Estes Park Trail-Gazette*. Also, a big thanks goes to author James Pickering, who wrote so many excellent local histories, and Ted Schmidt for his Colorado–Big Thompson Project slide show and Ray Fitch video.

This book would not be possible without area museums and the Estes Valley Library. At the Estes Park Museum, thank you Derek Fortini for looking over my list and Bryon Hoerner, Alicia Mittleman, and Naomi Gerakios for digging out all those photographs. Carie Essig at the YMCA of the Rockies Lula W. Dorsey Museum and Kelly Cahill at the Rocky Mountain National Park Museum Storage Facility were super in responding to my relentless requests for pictures. Kathleen Kase, Mark Riffle, and Keturah Young at the Estes Valley Library were very patient with my endless requests to see the archives. Thank you to Shannon Clark at MacGregor Ranch for the great MacGregor photographs.

Many generous people shared their Estes Park stories and pictures. Thank you to all who I interviewed and featured in the book, as well as Diane Rayburn, Jackie Hutchins, Kurtis Kelly, Debbie Richardson, Teddie Haines, Pat Washburn, Kim Stevens, Rosa Thomson, Rita Mayhew, Katie Webermeier, Jack Melton, Sybil Barnes, Brian Brown, John Meissner, Fran and Jay Grooters, Howell Wright, Kerrie Hill, Dave Tanton, Elah Bethel, Bonnie Watson, Ken Springsteen, Ann Neering, Gerald Mayo, Scott and Julie Roederer, John Cordsen, and Lois Smith.

I want to thank photographers James Frank, Tony Bielat, Heidi Wagner, Emily Rogers, and Kris and Gary Hazelton for sharing their work. And a special thanks to my wife, Lori Mitchell, who seems to know everyone in town and how they are related to each other.

INTRODUCTION

Writing this book has been a fascinating journey into the history of Estes Park and the lives of many interesting people—some whom I knew about and many whom I discovered along the way.

I learned more about well-known figures such as Enos and Joe Mills, F.O. Stanley, William Allen White, and the MacGregors from James Pickering's excellent books on Estes Park history. Oral histories, old newspaper articles, and personal interviews provided a peek into the rich lives of people who might not appear in most history books, like Albin Griffith and his sawmills, editor Tim Asbury at the award-winning *Estes Park Trail-Gazette*, teacher Casey Martin and his train, animal lover Carolyn Fairbanks, and philanthropist Katie Speer.

Well-known landmarks have stories of their own. Most everyone knows the connection between the Stanley Hotel and Stephen King's *The Shining*, but few know of Ralph Gwynn and the personal reason he built the tower on the Historic Park Theater. Many watch the Aerial Tramway glide up the side of Prospect Mountain, but few know about the engineer who designed it. At the YMCA of the Rockies, the Sweet Memorial Building, Ruesch Auditorium, and Hyde Chapel are named after men who made a difference.

The town often called on its hardworking citizens to become leaders. Henry and Bernie Dannels built houses, Henry Tregent pumped gas, Clarence Graves owned a gas company, and Ron Brodie sold groceries.

What was amazing were the connections. I would talk to one person and they would say, "Have you talked to so-and-so. She must be in the book!" Longtime resident Diane Rayburn suggested I talk to Bill Watson, so I learned about his father, "Pop," and his ice delivery business in the early 1900s. When I stopped by Glenna Dannels's house to look at photographs of her husband, Bernie, and his father, Henry, we talked about the Spectrum, a true artist's enclave on Elkhorn Avenue. While I looked at photographs of Bob Haines, his wife, Teddie, suggested I learn more about artist Herb Thomson and doctors Sam and Julie Luce. While picking up track photographs from Wendy Koenig Schuett, she suggested I learn more about Paul Van Horn and his work with the Colorado–Big Thompson Project.

Many of the connections are personal, and this book gave me an opportunity to connect with people I had not talked to in years. When I first arrived in Estes Park in 1979, EPURA director Art Anderson gave me my first job at his solar newspaper. My wife, Lori, worked at MacGregor Ranch, where she helped preserve the MacGregor family history, learned all about the MacGregors, and worked with Eric Adams and modern-day mountain man Tim Mayhew. During many summers, our son Jeff worked for the Colemans at Ride-A-Kart. And if you walked Elkhorn Avenue, you knew "Crazy Ed" Kelsch. I played basketball with history teacher Jeff Arnold and softball with football coach Perry Black, while our son Jeff learned how to play the trombone from band director Chuck Varilek.

Many Estes Park residents live and breathe its history. Debbie Burgess Richardson brought the Old Plantation Restaurant alive when she talked about her father, Bill Burgess, and his brother Bob. After I talked to downtown merchant Ernie Petrocine, I discovered that his father, "Pep," established a year-round catalog and opened the first computer store in town. When I bought a box of taffy at the Taffy Shop, I learned how new owner Mark Igel is continuing the tradition of this 80-year-old business. While working on a profile of George Hix, his daughter Kim Stevens sent me articles and photographs of his father, Charles, one of the founding fathers of Estes Park.

A book on Estes Park history would not be complete without Rocky Mountain National Park. Visionary Enos Mills fought for the establishment of the park, while early superintendent Roger Toll shaped it into what it is today. Rangers Jack Moomaw, Bob Haines, and Ferrel Atkins each brought their distinctive talents to the park. Rocky became a climbing mecca, thanks to Tom Hornbein, Steve Komito, and "Mr. Longs Peak" Jim Detterline, while Lisa Foster inspires the next generation with her mountain ascents. Hidden Valley was a hidden gem for ski enthusiasts, thanks to the efforts of concessionaire George Hurt and ski jumper George Peck.

Estes Park has been welcoming visitors for years, beginning with early lodge owners Abner Sprague, Charles Edwin Hewes, and Joe Mills at the Crags and Gordon and Ethel Mace at the Baldpate Inn. Those who stayed at McGraw Ranch were "Roughin' it with Ease." Today, Dave and Karen Ranglos and their family are keeping a tradition alive at Glacier Lodge, while parents seeking to instill strong values in their children send them to Cheley Camp.

People have been doing business in downtown Estes Park since the turn of the last century, when Cornelius Bond sold lots on Elkhorn Avenue for $50. But the three-month summer season was short, and if it was not for grocer Ron Brodie extending credit to the locals, many would not have survived the winter. Looking for ways to extend the season, Jim Durward founded the Longs Peak Scottish-Irish Highland Festival, now one of the largest in the country. Today, Paula Steige continues her family tradition with one of the finest independent bookstores in Colorado, while young entrepreneurs Amy Hamrick, Rob and Julie Pieper, and Olga Orgeta de Rojas established thriving businesses that have stood the test of time.

What impressed me was the number of strong-willed women who were a big part of Estes Park history. Tough-as-nails homesteaders Anna Wolfrom Dove and Katherine Garetson staked out land and then opened shops to visitors. Muriel MacGregor ran MacGregor Ranch alone for 20 years after her parents died. Jean Weaver climbed mountains, skied at Hidden Valley, and started a recycling effort that is still going strong. Lennie Bemiss and Harriet Burgess preserved local history for others, and today, animal lover Carolyn Fairbanks finds homes for hundreds of animals a year. Wendy Koenig Schuett ran in the 1972 and 1976 Olympics, operates a successful audiology business, and serves on the town board.

It is no wonder artists are drawn to Estes Park's natural beauty. The paintings of Richard Tallant, Dave Stirling, Lyman Byxbe, Greig Steiner, and Herb Thomson are displayed around town. Photographers Fred Clatworthy and Ted and Lois Matthews laid the groundwork for contemporary photographers James Frank and Erik Stensland.

"Mountain Strong" describes local residents who will not back down in the face of forest fires and floods. When the Lawn Lake earthen dam gave way in the national park in 1982, Stephen Gillette was in the right place at the right time to do the right thing—warn Estes Park of the impending floodwaters headed for town. In 2013, floods came again, and the town found new heroes. Ken and Marsha Hobert raised money for flood repairs, and Steve and Becky Childs repaired the Glen Haven Store and inspired a community. Through it all, Fire Chief Scott Dorman and his volunteer firefighters were there to serve—putting out fires and saving people from floodwaters.

The profiles here are but the tip of the iceberg—a brief glimpse of the people who populate the history of Estes Park.

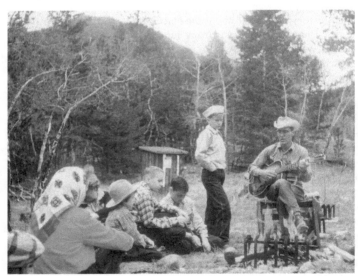

Campfire Songs with Bill Robinson
After a trail ride, Bill Robinson often sang songs around the campfire. His ghost story "The Blue Mist" told about a mysterious blue cloud that descended upon "Miner Bill" Currence's claim, struck his dog dead, and left a three-toed claw mark on a spruce tree. (Courtesy of Estes Park Museum.)

CHAPTER ONE

Settling the Estes Valley

The Estes Valley was well known to trappers, prospectors, and the occasional Indian hunting party before Joel and Patsey Estes began a modest cattle ranch on Fish Creek in 1863. But severe winters drove them out by the spring of 1966, and others followed. Griff Evans, who eventually took over the Estes homestead, hosted and guided visitors, such as travel writer Isabella Bird. The Rev. Elkanah Lamb, and later Enos Mills followed suit south of town in Tahosa Valley.

When the Earl of Dunraven saw the Estes Valley, he envisioned a private hunting ground where he could invite his guests. He built the Estes Park Hotel and bought up the land holdings through agents but met resistance from local landowners like Abner Sprague, who built lodges in Moraine Park and later Sprague Lodge next to his manmade lake. Lesser known but no less ambitious was Guy LaCoste, who wanted to buy Estes Park from Dunraven. The MacGregors and the James Family of Elkhorn Lodge ranched as well but hosted guests during the summer months. Woman homesteaders opened up shops to sell food and trinkets—Katherine Garetson at the Big Owl Tea Place and Anna Wolfrom Dove at the Wigwam Tea Room and Curio Shop. In 1905, Loveland grocer and sheriff Cornelius Bond formed the Estes Park Town Company and sold lots for $50 along newly formed Elkhorn Avenue. The Rev. Albin Griffith was not interested in hosting guests but in preaching and working the land. He built a sawmill at Bierstadt Lake to provide lumber for the Stanley Hotel and later moved it to Estes Park, where his family opened a lumberyard. After her parents, Donald and Maude, died in 1950, Muriel struggled to keep MacGregor Ranch running. In her will, Muriel arranged for the 1,200-acre ranch to be maintained in perpetuity as an example of turn-of-the-century high-altitude ranching.

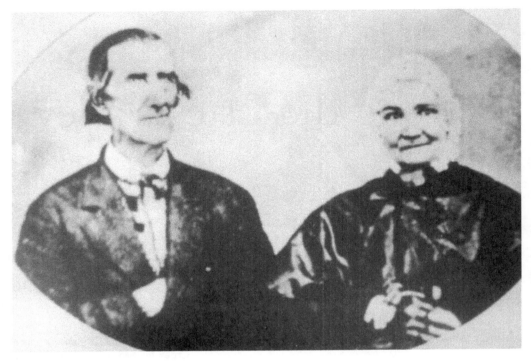

Pioneers Joel and Patsey Estes

In the fall of 1859, Joel Estes and his son Milton discovered the Estes Valley on a hunting trip. In 1863, Joel brought his wife, Patsey, and their children to the valley to try their hands at ranching. In August 1864, William N. Byers, founder and editor of the *Rocky Mountain News*, stayed with the Estes family during his unsuccessful attempt to climb Longs Peak. Byers named the beautiful valley Estes Park and predicted it would become a "favorite pleasure resort." But the winters were harsh, and the Estes family left for warmer climates in 1866. (Courtesy of Estes Park Museum.)

Griff Evans the Friendly Host

After Joel Estes left the valley in 1866, genial Welshman Griff Evans and his family ranched the place and hosted travelers, the first in Estes Park to do so. One of his guests was famous writer Isabella Bird, who he took riding in the mountains. Griff had a feud with "Rocky Mountain Jim" Nugent, and in 1874, Griff was arrested for shooting and killing him. When the case came to trial, charges were dropped because of lack of evidence. (Courtesy of Estes Park Museum.)

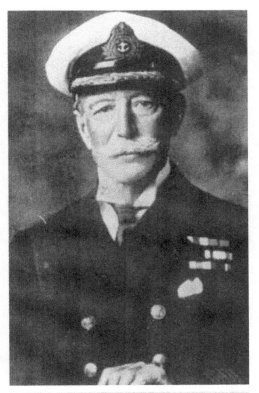

The Earl of Dunraven (1841–1926)
When Irishman Windham Thomas Wyndham-Quin, Fourth Earl of Dunraven first traveled to the Estes Park Valley in 1873, he became enthralled with its rugged beauty and wonderful hunting. Dunraven acquired 6,000 acres—some say by illegal means—and built the Estes Park Hotel in 1877. Whether Dunraven intended the land for raising cattle or a private hunting reservation is unclear, but soon he and his agents met stiff resistance from local settlers. By the mid-1880s, Dunraven lost interest in Estes Park and sold his land to F.O. Stanley and B.D. Sanborn in 1907. (Courtesy of Estes Park Museum.)

Land Speculator Guy LaCoste (1876–1934)
Newspaperman Guy LaCoste homesteaded 360 acres along the Wind River and soon expanded his holdings to 1,000 acres. In 1901, LaCoste incorporated the Estes Park Land and Investment Company with businessman George D. Sullivan and lawyer Arthur B. West, and opened the Wind River Lodge in the summer of 1902. He traveled to England to negotiate a lease with the Earl of Dunraven regarding his thousands of acres in the Estes Valley, but money problems squashed his plans. LaCoste's homestead property now comprises the core of the YMCA of the Rockies Estes Park Center's campus. (Courtesy of YMCA of the Rockies, Lula W. Dorsey Museum.)

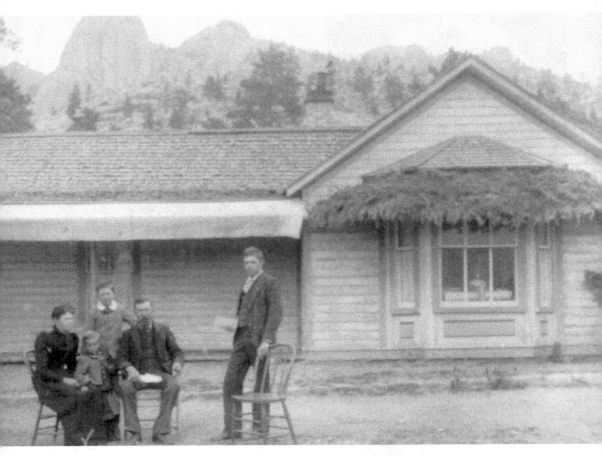

Alexander and Clara MacGregor and MacGregor Ranch

Alexander MacGregor brought his bride, Clara, to the meadows at the base of the Twin Owls in 1874. A former newspaper editor, lawyer, and businessman, MacGregor settled the land that was to become MacGregor Ranch and built a sawmill. With Marshall Bradford and his mother-law, Georgianna Heeney, MacGregor established the Park Road Company, which built a toll road between Lyons and Estes Park. In those early years, the couple spent winters in Denver, where MacGregor focused on his law practice. But when the weather warmed, he constructed a home (now the A.Q. House), post office, general store, and several tourist cabins, while maintaining a working cattle ranch. In 1896, MacGregor was struck and killed by lightning while checking on a mining claim above tree line, leaving Clara and three sons. Clara died five years later, and son Donald bought out the ranching interests of his brothers. With his wife, Maude, he increased the ranch size to more than 3,000 acres. Their only daughter, Muriel, operated the ranch for 20 years after both her parents died in 1950. (Courtesy of MacGregor Ranch.)

Preacher Elkanah Lamb (1932–1915)
When Elkanah Lamb was not preaching for the Church of the United Brethren, he built the Longs Peak House at the base of the 14,259-foot peak in 1875, from where he and his son Carlyle Lamb guided people to the top for $5 a trip. On one climb, 1,000 feet below the notch on a ledge known as Broadway, Lamb lost his footing and tumbled down a snowfield that is now known as Lamb's Slide. His wife, Jane Lamb, fed the guests, while his children took care of the cows. The Lambs sold Longs Peak House to Enos Mills in 1902. (Courtesy of Estes Park Museum.)

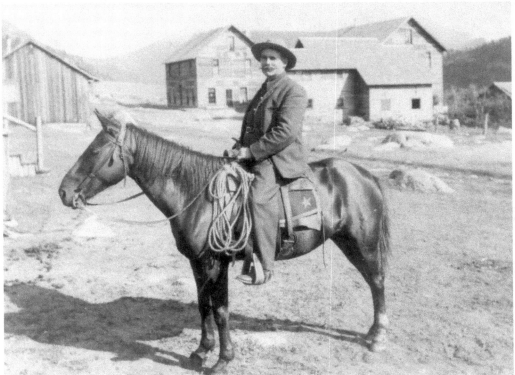

Innkeeper Abner Sprague (1850–1943)
During the brutal winter of 1975, Abner Sprague and his family huddled in a rough-hewn log cabin in Willow Park (now Moraine Park). After providing provisions to hunters, Sprague "suddenly realized there was more money in milking tourists than milking cows." He built a successful guest lodge in Moraine Park before selling his 1,000 acres on a handshake to John Stead. He then went back to surveying, platting downtown Estes Park for Cornelius Bond. However, Sprague returned to develop a resort in Glacier Basin. He dug a lake for his visitors that is now Sprague Lake. (Courtesy of Rocky Mountain National Park Archives.)

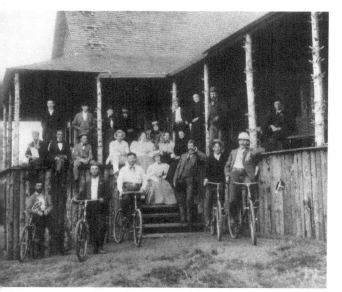

William James and Elkhorn Lodge

After a hunting trip to Estes Park in 1874, shopkeeper William James wired his wife, Eleanor James, in New York to sell their store and home and come west. They briefly homesteaded in Black Canyon but eventually settled on Fall River and built a cabin in 1877. At first, James raised cattle, but summer visitors begged to stay, so each winter they built another cabin before finally constructing Elkhorn Lodge. It was the site of Estes Park's first chapel, schoolhouse, golf course, icehouse, swimming hole, fish hatchery, and publicly funded trail through a national park. The Elkhorn Lodge is still in operation today. (Courtesy of Pieter Hondius.)

Katherine Garetson (1877–1963) Homesteads Big Owl

In her memoir *Homesteading Big Owl*, Katherine Garetson tells how she filed a three-year residency claim in 1914 and proved up a homestead at the base of Longs Peak. That first winter, Katherine and her friend A.A. (Annie Adele Shreve) learned how to provision a cabin, carry water up a hill, chop ice, shovel snow, saw frozen beef into steaks, wash, iron, scrub, and break through snow for the mail once a week. During their snowbound winter, Katherine and A.A. sewed doll clothes, aprons, towels, and pillow tops for the gift shop at their Big Owl Tea Place. Katherine homesteaded from 1914 to 1917. (Courtesy of Estes Park Museum.)

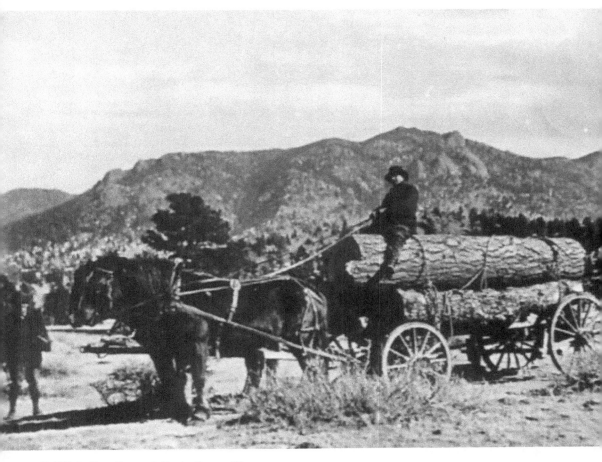

Griffith Family and their Sawmills

The Rev. Albin Griffith homesteaded land west of Estes Park in 1890 and, on weekends, ministered the United Brethren Church of Christ in Loveland. In 1907, he joined with his sons Dan and John Griffith to form the Griffith Lumber Company and provide timber for the construction of the Stanley Hotel. They built a sawmill near Bierstadt Lake and cut timber burned in the 1900 forest fire. The operation required nine men: three tree cutters, three running the mill, and three transporting the rough-sawn lumber from Bierstadt Lake to Estes Park. After three years, the Griffiths moved the mill to a location on Spur 66 where they also built their home. Fires in 1913 and 1927 destroyed the sawmill, but the Griffiths rebuilt and continued the lumberyard business. They bought another 14 acres in 1937–1938 and built Rockmount Cottages. In 1963, they sold the rental cabins, and a year later, Dan, at the age of 82, sold his inventory and leased his lumberyard ground. It became first Beaver's Lumber and then Everitt Lumber until September 1983, when grandson Don Griffith and his family sold the land. (Courtesy of Estes Park Museum.)

Cornelius H. Bond (1854–1931) and Downtown Estes Park

A former grocer and county sheriff from Loveland, Cornelius H. Bond moved to Estes Park in 1905 and formed the Estes Park Town Company with three associates. The company purchased the John Cleave Ranch at the confluence of the Big Thompson River and Fall River for $8,000. After Abner Sprague completed platting the land, the company offered 264 lots for sale—$50 for prime lots and $35 for those farther east. Those eager to establish businesses snatched up the lots. An amended plat in 1908 designated 14 lots as a park, which the town named Bond Park in 1944. (Courtesy of Estes Park Museum.)

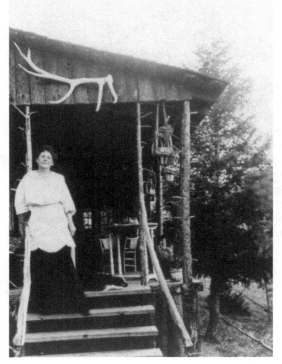

Anna Wolfrom Dove (1872–1950) and the Wigwam Tea Room

Dissatisfied with teaching in Kansas City, Anna Wolfrom built a log cabin along the Wind River Trail in 1913 with the aid of a neighbor, carrying all her building supplies to the 160-acre homestead in a wheelbarrow. After she proved up her claim in 1914, Wolfrom opened the Wigwam Tea Room and Curio Shop for tourists, hosting more than a hundred guests a day. In the 1920s, Wolfrom opened businesses at Beaver Point, the location of the current Sundeck Restaurant, and on Elkhorn Avenue near the Sam Service Store. Wolfrom married Dr. Orville Dove in 1923. (Courtesy of YMCA of the Rockies, Lula W. Dorsey Museum.)

Charles Hix (1896–1984) and the Estes Park Bank

In 1912, the Estes Park Bank needed help, so its cashier asked teacher Alice Donovan for the boy who was the best at arithmetic. She sent 16-year-old Charles Hix, who had just completed eighth grade. Hix worked summers at the bank and during winters attended high school in Denver. After serving in the Army during World War I, he was named cashier and later served as bank president from 1937 to 1970, when he retired and became chairman. Hix became the first town clerk at 21, became a charter member and director of the chamber of commerce, and helped found the Estes Park Sanitation District. He served 39 years on the board and also served 15 years on the school board. Hix helped organize the Estes Park Golf and Country Club in 1917. He is pictured at right, and below in the back row at far left. (Both, courtesy of Kim Stevens.)

**Muriel MacGregor (1904–1970)
and MacGregor Ranch**
Today, the 1,200-acre MacGregor Ranch is an
example of a working, turn-of-the-century, high-
altitude ranch, thanks to the foresight of Muriel
MacGregor and the efforts of a group of dedicated
volunteers. Born in 1904, Muriel grew up on the
ranch playing with her dog Tiger and riding her
Shetland pony Zephyr. She was one of the first
woman lawyers in Colorado, earning a law degree
from the University of Denver in 1934. When her
parents, Donald and Maude MacGregor, died in
1950, Muriel worked the ranch homesteaded in
1873 by her grandparents Alexander and Clara
MacGregor. But bills mounted and the cows broke
through fences, causing conflicts with neighbors.
When Muriel died in 1970, her will directed that
MacGregor Ranch be left in trust for charitable and
educational purposes. The Muriel L. MacGregor
Charitable Trust was formed in 1978. (Courtesy of
MacGregor Ranch Museum.)

CHAPTER TWO

A Warm Welcome

Those who settled in Estes Park learned that it was easier to host guests drawn by the valley's incredible beauty than it was to grow crops or raise cattle. Early settler Abner Sprague quit raising cows and built two lodges to host visitors in what is now Rocky Mountain National Park. Elkanah Lamb and Enos Mills hosted visitors at their lodges at the base of Longs Peak and guided people up the mountain. Neighbor Charles Edwin Hewes welcomed visitors to his hotel in the summer while writing epic poetry in the winter. Inventor F.O. Stanley moved to Estes Park for his health and built the Stanley Hotel in 1909 to welcome visitors who rode Stanley Steamers to his hotel up the canyon road he helped finance. Gordon and Ethel Mace constructed their inn from hand-hewn timber and named it after the hotel in the Earl Derr Biggers mystery novel *Seven Keys to Baldpate*. Guests still bring keys to its world-famous key room. Frank Cheley established the Bear Lake Trail School in the early 1920s on the shores of Bear Lake to introduce boys to nature. Cheley Camp continues to welcome young people today. In 1907, Bruno Hobbs and William Sweet were instrumental in establishing the YMCA of the Rockies near Estes Park, but it was Walter Ruesch in the 1950s and 1960s who transformed the summer-only camp into a world-class, year-round facility. Joe Mills was an athlete, coach, and writer who built and managed the Crags Lodge that still overlooks downtown Estes Park. After GOP presidential hopeful Alf Landon stayed in 1936, McGraw Ranch slowly made the transition to a guest ranch, welcoming families year after year with the motto "Roughin' it with Ease." For 40 years, Andy and Marty Anderson welcomed tourists to their cottages with "wonderful views" of Longs Peak. Stable concessionaires Bill and Fannye Robinson made sure tourists were comfortable on the back of a horse. Afterward, Bill sang cowboy tunes and told ghost stories around the fire. Jim Ranglos played in the Final Four for the University of Colorado Buffs basketball team, but rather than play professional ball, he and his wife, Penne, started the family-operated Glacier Lodge.

Charles Edwin Hewes (1870–1947) and the Hewes-Kirkwood Inn
To become a guest at the Hewes-Kirkwood Inn was to become a friend of Charles Edwin Hewes. A religious man with writing aspirations, Hewes arrived in Estes Park in 1907 at the age of 37 and went to work for Enos and Joe Mills at the Longs Peak Inn. But soon, he and his brother Steve Hewes, along with their mother, Mary Kirkwood, homesteaded nearby and built cabins. For the next 40 years, Hewes navigated through financial difficulties as owner-proprietor of the Hewes-Kirkwood Inn. "One furniture firm threatened to attach the very beds our guests were sleeping in," Hewes wrote. Loyal guests often donated money to keep the lodge afloat. During the quiet winter months, Hewes wrote stories, novels, and epic poems, including his poetry collection *Songs of the Rockies*. Today, the Hewes-Kirkwood Inn is the site of the Rocky Ridge Music Center. (Courtesy of Estes Park Museum.)

Town Father F.O. Stanley (1849–1940) and the Stanley Hotel
When F.O. Stanley received a diagnosis of tuberculosis at the age of 53, he moved his family to Colorado in 1903, hoping the mountain air would save his life. Stanley drove his Stanley Steamer up the dirt roads to Estes Park, where he built the Stanley Hotel in 1909, and ferried guests to his rooms in 13 Stanley Steamer buses. Not only did Stanley attract wealthy guests to his hotel, but he became an Estes Park town father, investing in the Big Thompson Road from Lyons to Estes Park, forming the Estes Park Electric Light and Power Company, and constructing the Fall River Hydroelectric Power Plant. A former schoolteacher and principal, Stanley donated land to build a school. Stanley supported the formation of Rocky Mountain National Park, writing letters to Congress and backing Enos Mills on his speaking tour. Stanley also donated land that eventually became Stanley Park and Fairgrounds, home of the Rooftop Rodeo and ball fields. His wife, Flora Stanley, was a leader on the Ladies' Auxiliary of the Estes Park Protective and Improvement Association, which would become the Estes Park Woman's Club. The club promoted trail building, the fish hatchery, and Estes Park's first library. For someone given only a year to live with his tuberculosis diagnosis, Stanley lived a long, productive life of 91 years. (Courtesy of Estes Park Museum.)

The Cheley Family and Cheley Camps

Frank Cheley wanted boys who were "self-propelled, independent individuals with real character and personality," so he established the Bear Lake Trail School in the early 1920s on the shores of Bear Lake in Rocky Mountain National Park. These leadership training camps became so popular that he welcomed "vigorous girls" to Camp Chipeta in 1926. Now more than 90 years later, the Cheley family carries on Frank's legacy at their camp properties near Estes Park. After Frank's sudden death in 1941, son Jack and his wife, Sis, carried on the family tradition. Today, after expanding and modernizing Cheley Camps, Don and Carole Cheley have turned over daily operations to their son Jeff Cheley and daughter Brooke Cheley-Klebe for a new generation of campers. Through the years, Cheley's mission has remained the same: "We build the lasting character and resiliency of young people, creating unique life experiences in a challenging and nurturing natural environment." Pictured are Jeff and Erika Cheley with their children. (Courtesy of Jeff Cheley.)

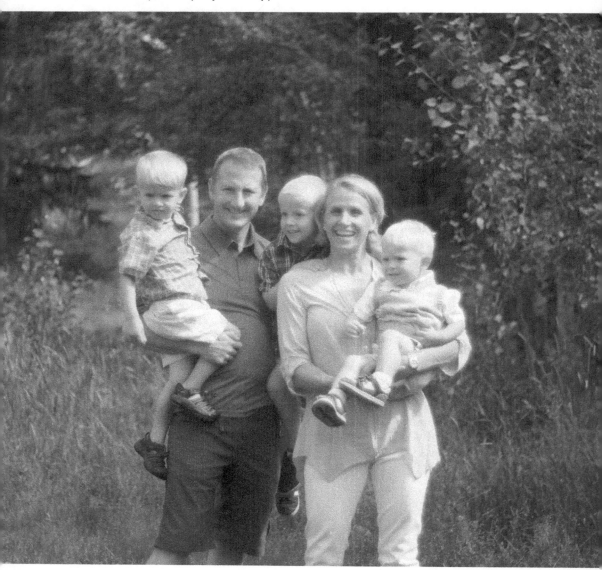

Gordon (1884–1959) and Ethel Mace (1889–1983) and the Baldpate Inn Guests who stay at the Baldpate Inn often bring a key for the inn's world famous key room. The Inn's 20,000-key collection is the largest in the world, with keys from the Pentagon, Westminster Abbey, and Mozart's wine cellar. In 1911, Gordon and Ethel Mace homesteaded the property and later constructed the Baldpate Inn—the name inspired by author Earl Derr Biggers, who featured an imaginary Baldpate Inn in his mystery novel *Seven Keys to Baldpate*. From that day forward, each guest received a key, until World War I made the price of metal too expensive. Disappointed, guests brought keys to give to the Maces, and the key room was born. The Smith family bought Baldpate Inn in 1986 and have kept the traditions alive. (Both, courtesy of Estes Park Museum.)

YMCA Pioneer Bruno Hobbs (1867–1909)

Bruno Hobbs is often credited with helping found the YMCA of the Rockies. After graduating with a law degree from the University of Kansas in 1889, Hobbs married, moved to Cripple Creek, and began a career in banking. But he quit banking to work for the YMCA full-time, organizing the Grand Lake Conference in 1907. With William H. Sweet and four others, Hobbs hiked from Grand Lake to Estes Park, where they stayed at the Wind River Lodge. In 1909, the Wind River land was purchased, and the YMCA of the Rockies was born. (Courtesy of YMCA of the Rockies, Lula W. Dorsey Museum.)

YMCA Champion William Sweet (1869–1942)

During the summer of 1907, the YMCA met at Grand Lake to scout sites for a summer school. Finding nothing suitable, William E. Sweet led a group of six men over the Continental Divide to stay overnight at Wind River Lodge. After a successful summer camp in 1908, the YMCA purchased Wind River Ranch for the YMCA of the Rockies. Sweet was active in the YMCA movement in Colorado, giving one-fifth of his fortune to build the Denver YMCA building. He was president of the Denver chapter for 22 years. Sweet also served as Colorado governor from 1923 to 1925. (Courtesy of YMCA of the Rockies, Lula W. Dorsey Museum.)

Philanthropist Albert Alexander "A.A." Hyde (1848–1935)
Faith and health were the driving forces behind Albert Alexander Hyde's successful life. Every morning, the devout Presbyterian knelt with his family, recited Bible verses, and said a prayer. His Mentholatum Company made an ointment of petroleum and menthol that relieved pain, eased itches, cured colds, and soothed insect bites. Its popularity made Hyde a rich man, and he used those riches to support the YMCA—specifically, the YMCA of the Rockies. He pledged $10,000 to reduce the YMCA's debt and purchased 78 acres north of the YMCA grounds for Fellowship Park. In 1957, the YMCA dedicated the Hyde Memorial Chapel. The Hyde Family Foundation helped fund the Pattie Hyde Barclay Reunion Lodge in memory of Hyde's youngest daughter, Pattie. (Both, courtesy of YMCA of the Rockies, Lula W. Dorsey Museum.)

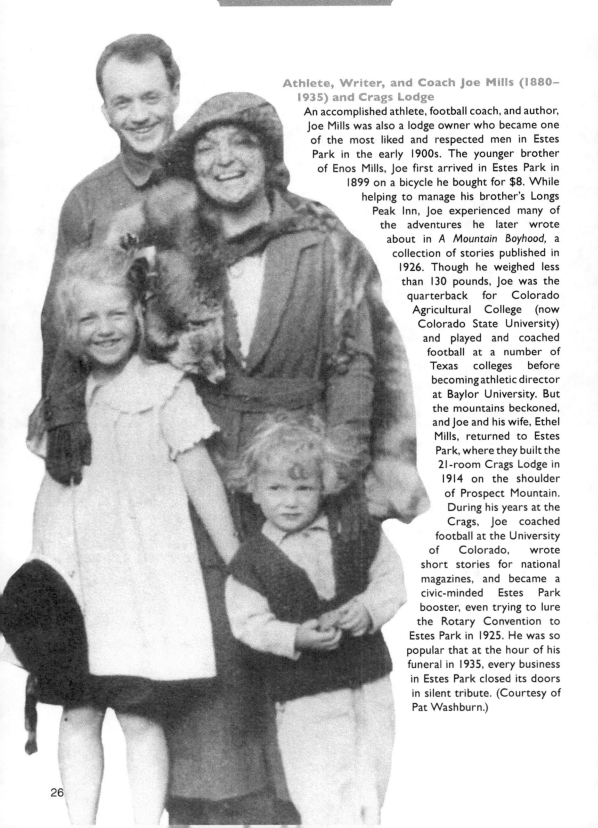

Athlete, Writer, and Coach Joe Mills (1880–1935) and Crags Lodge

An accomplished athlete, football coach, and author, Joe Mills was also a lodge owner who became one of the most liked and respected men in Estes Park in the early 1900s. The younger brother of Enos Mills, Joe first arrived in Estes Park in 1899 on a bicycle he bought for $8. While helping to manage his brother's Longs Peak Inn, Joe experienced many of the adventures he later wrote about in *A Mountain Boyhood,* a collection of stories published in 1926. Though he weighed less than 130 pounds, Joe was the quarterback for Colorado Agricultural College (now Colorado State University) and played and coached football at a number of Texas colleges before becoming athletic director at Baylor University. But the mountains beckoned, and Joe and his wife, Ethel Mills, returned to Estes Park, where they built the 21-room Crags Lodge in 1914 on the shoulder of Prospect Mountain. During his years at the Crags, Joe coached football at the University of Colorado, wrote short stories for national magazines, and became a civic-minded Estes Park booster, even trying to lure the Rotary Convention to Estes Park in 1925. He was so popular that at the hour of his funeral in 1935, every business in Estes Park closed its doors in silent tribute. (Courtesy of Pat Washburn.)

"Roughin' it with Ease" with Frank (1913–1983) and Ruth McGraw (1916–2010)
"Roughin' it with Ease" was the motto at Frank and Ruth McGraw's dude and guest ranch on Cow Creek. What made it one of the most successful guest ranches in the Rockies was the good old-fashioned family hospitality. Frank's parents, John and Irene, purchased the ranch in 1909 and raised cattle and horses in addition to running a wood business. After William Allen White brought GOP presidential hopeful Alf Landon to the ranch in 1936, McGraw Ranch slowly made the transition from a working ranch to guest ranch. Born on the ranch in 1913, Frank returned after serving in the Army in World War II and married Ruth Hodson in 1947. They assumed management of the ranch from his mother, Irene, in 1955 and continued to run it until 1979. Frank and Ruth's five daughters—Sally, Frances, Anne, Ruthie, and Cathy—helped run the ranch during the summers. In 1988, Rocky Mountain National Park purchased McGraw Ranch with the intent to return the land to its natural state, but local opposition convinced the park otherwise. A historic preservation project was completed by the park in the fall of 2003, and McGraw Ranch is now a research facility with overnight accommodations, a small lab, kitchen facilities, and work space for researchers. (Courtesy of Fran and Jay Grooters.)

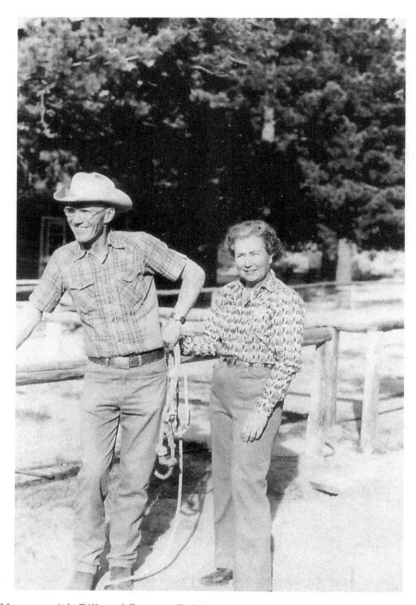

Riding Horses with Bill and Fannye Robinson

The campfire flickered as adults and children gathered around. "Something was wrong at Miner Bill's," wrangler Bill Robinson began. "The Blue Mist" is a spine-chilling ghost story about a mysterious blue cloud that descended upon "Miner Bill" Currence's claim, struck his dog dead, and left a three-toed claw mark on a spruce tree. Robinson insisted that it was only a tall tale, but many campers slept with one eye open. Born in Denver in 1927, Robinson worked at Art Card's livery in Estes Park during the summers. After a tour in the Army, Robinson graduated from Colorado State University in 1951, but his interest was always horses and the people who rode them. Robinson married Fannye Kingston in 1954, and together they ran liveries at Fall River Lodge and Steads Ranch before taking over the YMCA livery operation in 1963. They ran it until 1977, telling stories and showing "greenhorns" how to ride horses. (Courtesy of Estes Park Museum.)

YMCA Visionary Walter Reusch (1909–1986)

When Walter Ruesch accepted the job as managing director of the YMCA of the Rockies in 1950, he planned to stay only three years. He retired 30 years later, after transforming the Estes Park Center from a three-month summer camp into a modern, year-round conference and family vacation center. Every day, Reusch followed his motto "we have no problems, only challenges and opportunities" as he convinced the YMCA board members to winterize cabins and drill wells. In 1969, Snow Mountain Ranch was opened in Grand County, which offered wonderful winter sports opportunities. The YMCA of the Rockies honored Reusch in July 1980 with the dedication of the Walter G. Ruesch Auditorium. After his death in 1986, his wife, Alice Reusch, established a scholarship fund to aid seasonal staff and children of year-round employees with the cost of higher education. (Courtesy of YMCA of the Rockies, Lula W. Dorsey Museum.)

E.R. "Andy" (1917–2013) and Marty Anderson (1922–2012) and Anderson's Wonderview
No one who has ever lived in Estes Park will forget Andy Anderson's big smile and happy hello. Born E.R. Anderson in Denver in 1917, Andy graduated from Denver's Manual High School in 1935 and Colorado State University in 1940. He grew to love Estes Park while working summers at the original Trout Haven and nearby Conoco station. While working at McDonnell-Douglas in California, Andy met and married Marty, his wife of 66 years. After World War II, Andy and Marty purchased cottages on High Drive. With Marty's charm and elegance at the front desk, Anderson's Wonderview Cottages was rated among the top 10 destination resorts in northern Colorado by 1970. While Marty ran the cottages, Andy opened a liquor store that he expanded into Jolly Jug Liquors. His business complex included Trout Haven and a filling station. After the brief summer season, Andy worked winters for local contractors, electricians, and Graves Gas, while Marty opened a dance school for children to support their growing family of seven. Still, Andy was a Lions member for years and president of the chamber of commerce board in 1960. Marty served on the school board and volunteered for Quota Club, which helped bring the first ambulance to Estes Park. Both were interested in local history. Andy wrote *The High Drive Area in the 1800s*, *Trout Haven 1933 to 1967*, and *Our Lady of the Mountains 1910 to 2007*, and Marty began the Old Timers Club, which met once a week. Andy and Marty sold the downtown businesses in 1981 and Anderson's Wonderview in 1986. (Courtesy of Estes Park Museum.)

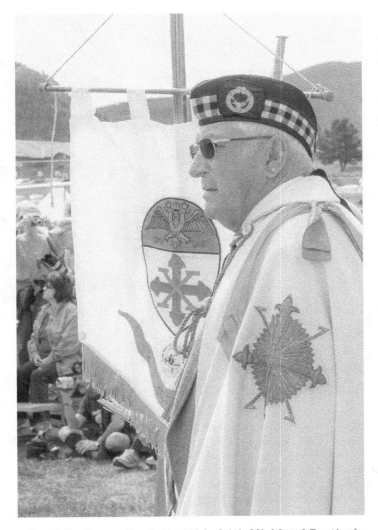

James Durward and the Longs Peak Scottish-Irish Highland Festival
When a group of town leaders discussed ways to extend Estes Park's 100-day summer season in 1976, James Durward suggested holding a Scottish-Celtic festival. That fall, Neil Gillette played the pipes, his wife, Sherry, performed Highland dances, and Polly Ann Baird sold cookies to a small crowd at Centennial Plaza. From these modest beginnings, Estes Park's Longs Peak Scottish-Irish Highland Festival has grown into one of the largest and most respected Scottish festivals in North America. In 1967, Durward moved with his family to Estes Park and bought a dental practice. He redesigned and rebuilt his office into the waterwheel complex, and dove into town politics, becoming chamber of commerce president in 1971. But the festival soon became his true passion. At first, with little support from the town, Durward poured his own money into the event and relied on an army of loyal volunteers to take tickets at the gate and put up the bleachers he scavenged from Colorado State University. Durward invited pipe bands from across the world to participate, including the Scots Guard and the Black Watch. Now, in its 38th year, the festival includes a tattoo, jousting, and Scottish athletic events and educational programs. Also featured are dogs of the British Isles, Irish and Highland dance, folk music, and thousands of people dressed in kilts enjoying the Estes Park weather that reminds them of the Scottish Highlands. (Courtesy and copyright of James Frank.)

Jim and Penne Ranglos and Glacier Lodge

Nicknamed the "Golden Greek" during his basketball days at the University of Colorado, Jim Ranglos played in the Final Four in 1955 and was named to the All-NCAA Tournament Team. But rather than play pro ball, Jim married Penne Tiller in 1957 in Iowa, where they both taught school. Penne grew up in Estes Park, where her family operated the Log Cabin Waffle Shop downtown, so it was her local roots that brought the couple back and inspired the purchase of the former Voekel's Glacier Lodge in 1974, which Jim and Penne renamed Glacier Lodge. The lodge had not been operated in years, so the couple removed the plywood covering the windows and doors and cleaned the place out, finding a surprise behind every door. They added poolside family cabins in the early 1980s and riverside duplex and triplex buildings in the late 1980s and 1990s. During that time, Jim was active in civic affairs, serving two terms on the Estes Park chamber board, four years on the board of education—including a term as president—and as a member of the Accommodations Association board of directors. He was also president of the Rotary Club. Jim and Penne were among the first organizers of Parents and Community for Kids (PaCK) and early advocates for a youth center. Penne was involved with the Quota Club. After Jim and Penne died in 1998, David and Karen Ranglos and their two children, Jack and Lauren, took over daily operations. Here, Penne Ranglos is on the far right and Jim Ranglos is in the back wearing the white hat. (Courtesy of Ranglos family.)

CHAPTER THREE

The Park Experience

The Rocky Mountains bring a special brand of people to the Estes Valley. Take Enos Mills, who led the fight to establish Rocky Mountain National Park, which Congress made a national park in 1915. To help Mills reach his goal, Shep Husted guided Arapaho elders across the Continental Divide during the summer of 1914 to name the valleys and peaks for the new park. Roger Toll became the third superintendent of Rocky Mountain National Park in 1921 and undertook an ambitious building program, expanded the park, advocated the building of Trail Ridge Road, and hired Jack Moomaw as the first year-round ranger. Moomaw was the only ranger on the east side during the winter, making rescues and skiing across the Continental Divide in the course of a day's work. Dorr Yeager was the first Rocky Mountain National Park naturalist and helped found the Rocky Mountain Nature Association in 1931. He organized lectures, self-guided nature walks, and field trips, fictionalizing the life of a ranger in his popular Bob Flame novels. After earning a Purple Heart with the 10th Mountain Division in Italy during World War II, George Hurt ran the concession at the Hidden Valley ski area, while daredevil ski jumper George Peck promoted the area. Mathematics professor Ferrel Atkins, a seasonal ranger from 1952 to 1984, led interpretive hikes and researched park history. Ranger Bob Haines was the consummate "ranger's ranger." Not only was Haines a mountaineer, winter skills enthusiast, and emergency medical technician (EMT), he was also a naturalist, certified SCUBA diver, and an outstanding photographer. Jim Detterline was supervisory climbing ranger on Longs Peak from 1987 to 2009 and participated in more than 1,200 rescues. Known as "Mr. Longs Peak," Detterline climbed the mountain more than 400 times. When climbers arrived in Estes Park in the 1970s, they would usually head over to Steve Komito's boot repair shop to swap stories, make plans, and sometimes sleep on the floor before an early morning climb in the park. One of the few custom bootmakers in the country, John Calden has been making boots for serious hikers for decades. Guide Lisa Foster holds the Longs Peak female ascent record and has hiked and climbed to every destination listed in her book *Rocky Mountain National Park: The Complete Hiking Guide*.

Enos Mills (1870–1922), the Father of Rocky Mountain National Park

After a chance encounter with naturalist John Muir, Enos Mills devoted his life to conservation and inspired people about nature through his articles, books, and tireless speaking schedule. A sickly youth who moved to Colorado for his health, Mills regained his health and climbed Longs Peak for the first time when he was only 15 years old. He fell in love with the 14,259-foot mountain, climbing it more than 300 times during his lifetime. At his Longs Peak Inn at the foot of the mountain, Mills welcomed guests but did not allow music or dancing in an attempt to reflect the quiet tranquility of nature. Mills led the fight to establish the Rocky Mountain National Park, and Congress made it a national park in 1915. (Both, courtesy of Rocky Mountain National Park Archives.)

Guide Shep Husted (1867–1942)

There was only one man suited to guide and equip the two-week pack trip that took the Arapaho elders across the Continental Divide on the Ute Trail that summer of 1914. Clem Yore wrote in the *Estes Park Trail* on January 27, 1922: "The white man guide who went with them was Shep Husted, almost an Indian himself in his uncanny knowledge of the hills and his love of them." Shepherd "Shep" Husted arrived in Estes Park in 1887 and worked as a carpenter for Scotsman John Cleave. He and his wife, Clara Husted, homesteaded in Devils Gulch north of Estes Park, building the Rustic Hotel and opening it to tourists in 1901. However, Shep's heart was not in the hotel business but in guiding hundreds of visitors in the surrounding Rocky Mountains. As a result, the hotel struggled, and Shep sold it in 1907, turning his energies to guiding and becoming an expert on the Rocky Mountains. Shep climbed Longs Peak hundreds of times, even guiding novelist Edna Ferber to the top. (Courtesy of Estes Park Museum.)

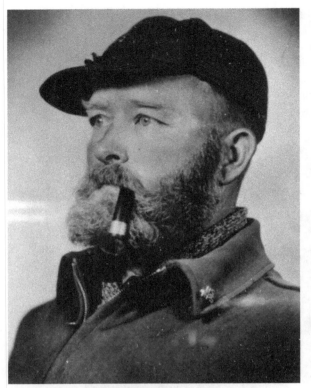

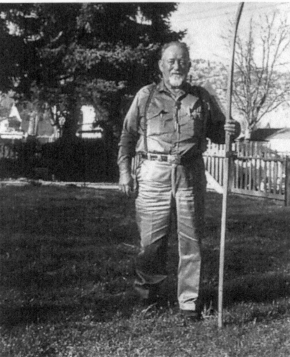

Ranger and Author Jack Moomaw (1892–1975)

After Jack Moomaw made the first recorded January ascent of Longs Peak, Rocky Mountain National Park director Roger Toll hired him as the park's first year-round ranger in 1922. The only ranger on the east side during the winter months, Moomaw surveyed, supervised, and built the foot trails on the east side of the park. He was an expert at skiing over the Continental Divide to Grand Lake and then returning the same day. He was one of the first to climb the east face of Longs Peak, and he placed the cables on its north face. Moomaw designed "Suicide Trail" at Hidden Valley, the site of the second annual US National Amateur Ski championships. Moomaw's book *Recollections of a Rocky Mountain Ranger* reveals what it was like to be a ranger in the park's early days. (Top, courtesy of Rocky Mountain National Park Archives; bottom, courtesy of Robert J. and Theodora A. Haines.)

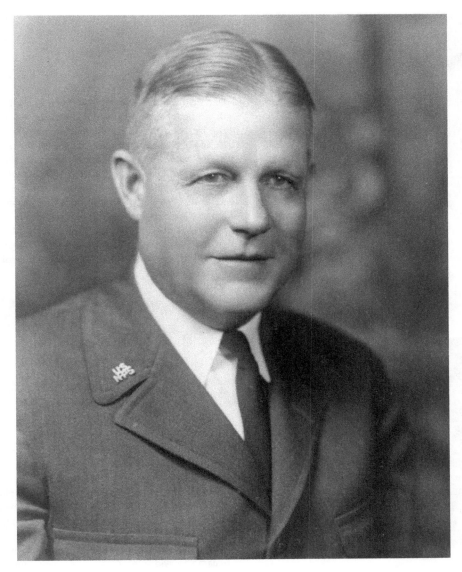

Superintendent Roger Toll (1883–1936)

It was Roger Toll's vision for US national parks that made him special. He became superintendent of Rocky Mountain National Park in February 1921 and led an ambitious building program, expanding the park to include Gem Lake, Deer Mountain, and Twin Sisters. He also resolved several conflicts that had simmered with the local communities of Estes Park and Grand Lake. A passionate mountaineer, Toll joined the search for his cousin Agnes Vaille on Longs Peak and, with Robert Sterling, authored the guidebook *Mountaineering in Rocky Mountain National Park*. Under his leadership, ranger-naturalists led all-day nature study trips and held evening talks, many featuring lantern slides. Toll advocated the construction of Trail Ridge Road, which was in the planning stages by the time he left for Yellowstone in 1929. That year, more than 300,000 people visited Rocky Mountain National Park. Tragically, Toll was killed in a car accident in 1936 while investigating establishing international parks along the US-Mexico border. Today, park visitors may hike the half mile to the Toll Memorial on Trail Ridge Road. (Courtesy of Rocky Mountain National Park Archives.)

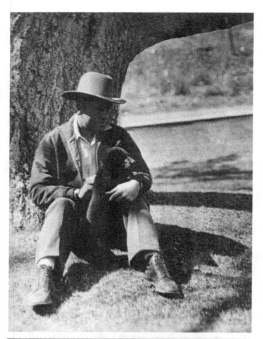

Ranger Dorr Yeager (1902–1996) and the Bob Flame Novels

Bob Flame rescued stranded hikers, hunted down poachers, and stood tall without fear in the face of danger. Readers learned about the duties of a Rocky Mountain ranger on the pages of *Bob Flame: Rocky Mountain Ranger*, published in 1935 by Dorr Yeager. Born in 1902, Yeager was the first Rocky Mountain National Park naturalist and helped found the Rocky Mountain Nature Association in 1931. He organized lectures, self-guided nature walks, and field trips. At the Crags Lodge, Dorr met his wife, Eleanor Ann Mills, daughter of Joe Mills. (Courtesy of Pat Washburn.)

Ski Jumper George Peck (1918–2011)

Imagine jumping on wooden skis with old-fashioned bindings. In the 1930s, George Peck loved ski jumping, whether it was on Davis Hill or Old Man Mountain. He organized local events and contests and helped promote ski jumping as a major sport in Colorado. Born in Denver in 1918, Peck moved to Estes Park in grade school and became an avid skier. After participating on the Colorado College–Colorado Springs ski team, Peck served four years as a carrier pilot during World War II. On his return, he promoted Hidden Valley Ski Area as a popular destination. Peck was Estes Park postmaster from 1951 until 1973. (Courtesy of Estes Park Museum.)

George and Phyllis Hurt and the Hidden Valley Ski Area

After he earned a Purple Heart while serving with the 10th Mountain Division in Italy during World War II, George Hurt returned to Estes Park and became the first concessionaire at Hidden Valley Ski Area. His wife, Phyllis Hurt, sold hotdogs in the lunch shack while George worked to keep the ski lifts running. George installed rope tows on the upper and lower slopes and used car and marine engines to run them. George and Phyllis worked at Hidden Valley from 1947 to 1955, and after a brief stay in Hot Sulphur Springs, returned to the ski area to work for Ted James and the Rocky Mountain Park Company. George got the upper T-bar working correctly and built a snowpacking machine. George and Phyllis raised four children who grew up at Hidden Valley. (Both, courtesy of Hurt family.)

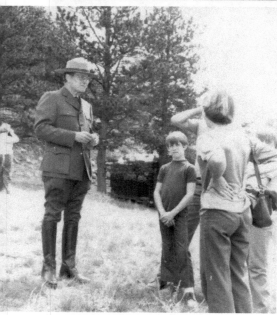

Ferrel Atkins (1924–2011)
Preserves Park History

The first thing one noticed before going on a nature hike with Dr. D. Ferrel Atkins was the leather boots to the knee, bloused trousers, and smart ranger hat. With a PhD in mathematics from the University of Kentucky, Atkins taught mathematics at the University of Eastern Illinois during the school year and served as a seasonal ranger at Rocky Mountain National Park every summer from 1952 until 1984. He led interpretive hikes and horseback tours, and gave slide programs. Atkins's passion was park history research, turning the hours he spent in the library into interpretive programs. Atkins kept the story of William Allen White's years at Moraine Park alive until it was published as the book *If I Ever Grew Up and Became a Man: William Allen White's Moraine Park Years* by James Pickering. (Both, courtesy of Rocky Mountain National Park Archives.)

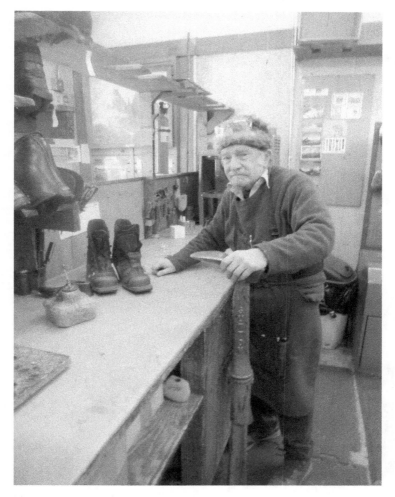

Master of Boot Repair Steve Komito

When climbers arrived in Estes Park in the 1970s, they would usually head over to Steve Komito's boot repair shop in the old Rocky Mountain National Park building. There, they would swap stories, make plans, and sometimes sleep on the floor before an early morning climb in the Park. He offered a welcoming community for active mountaineers in the middle of a tourist town. "Maybe I was Peter Pan, and this was the land of the lost boys and a few lost girls," Komito said in an Estes Park Museum interview. Born in 1941 in Fort Wayne, Indiana, Komito could not wait to leave for the mountains and the University of Colorado. His parents called him *meshugge* (Yiddish for crazy), but climbing was more interesting than attending engineering classes, so Komito dropped out of school to climb and supported himself by working at several outdoor sports stores in Boulder. He was 21 when he made first ascents with legendary climber Layton Kor of the now-closed Left Mitten Thumb in Monument Valley and Standing Rock in Canyonlands National Park. Komito also appeared on the cover of *Climbing* magazine ascending the south ridge of Notchtop. After taking a few evening shoe repair classes in Denver, Komito opened a boot repair shop in Boulder in the spring of 1969 and, when student protests escalated, moved to Estes Park in 1971. Now, 43 years later, Komito has a thriving boot repair business at a location that he has occupied since 1986, with two-thirds of his repairs coming from people who have never set foot in his shop. Today, he enjoys hiking, cross-country skiing in the backcountry, and bagging an occasional peak. (Courtesy of Steve Mitchell.)

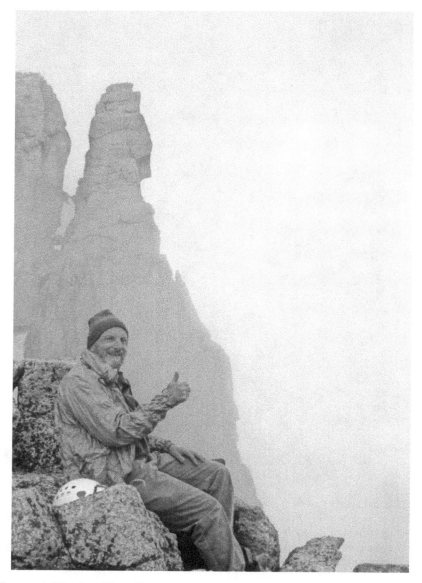

Mount Everest Climber Tom Hornbein Calls Estes Park Home
In 1963, Dr. Tom Hornbein and Willi Unsoeld made the first ascent of the West Ridge of Mount Everest, enduring a forced, overnight bivouac at 28,000 feet. Hornbein fell in love with the mountains at the age of 13 while attending Cheley Camp's Trails End Ranch near Glen Haven. "It transformed my life when I discovered that mountains and cliffs had it all over houses and trees," he said, comparing the mountains to his home in St. Louis. Later, Hornbein became a counselor at Cheley during his college years at Boulder and was involved in Rocky Mountain rescue. While attending medical school at Washington University in St. Louis, he worked summers as a naturalist in Rocky Mountain National Park and climbed in his spare time, pioneering routes such as Zumie's Thumb and the Hornbein Crack. After graduating from medical school, Dr. Hornbein had a long career at the Departments of Anesthesiology and Physiology and Biophysics at the University of Washington. He returned to Rocky Mountain National Park in the early 1990s to climb and moved to Estes Park permanently in 2006. (Courtesy of Tom Hornbein.)

Ranger Robert "Bob" Haines (1921–2008)

Rocky Mountain National Park rangers seeking a role model should examine the career of Robert "Bob" Haines. A consummate "ranger's ranger," Haines was a mountaineer, winter skills enthusiast, EMT, naturalist, certified SCUBA diver, and an outstanding photographer. Born in 1921 in Omaha, Nebraska, Haines vacationed in the park five times before moving to Estes Park in 1954 with the intent of becoming a park ranger. In 1956, he was hired as caretaker of the Hidden Valley Ski Area, where he earned the name "Mayor of Hidden Valley." As a first aid instructor-trainer, Haines stabilized injured skiers before they were treated by a doctor. He carried his Hasselblad camera whenever he trekked into the backcountry and was soon giving slide programs throughout the community. After three months of training at the Grand Canyon National Park training center, Haines became a permanent park employee in 1969. As West District naturalist, Haines supervised seasonal naturalists and volunteers, took part in summer rescues, worked road patrol, and manned the visitor center front desk. For 10 years, Haines and his wife, Teddie, lived on the park's east side during the winter and on the west side in the summer. He also taught rangers winter mountaineering skills and children environmental studies. During his 23 years in Rocky, Haines worked in the maintenance, ranger, and naturalist divisions, often participating in park rescues. He retired from the National Park Service in 1980 but continued to give slideshows in Estes Park for years. (Courtesy of Robert J. and Theodora A. Haines; photograph by John Olsen.)

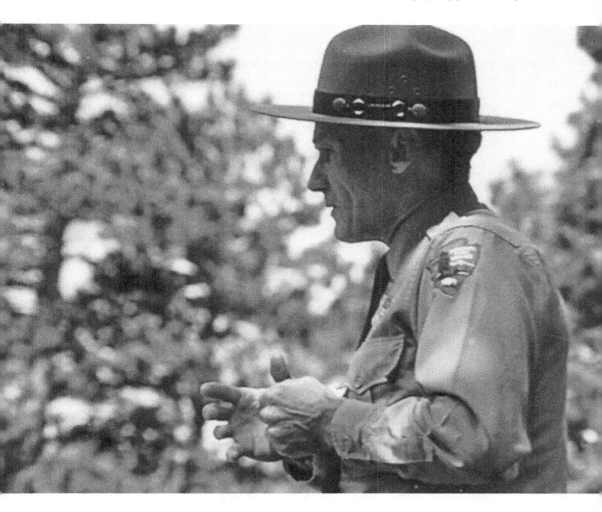

"Mr. Longs Peak" Dr. Jim Detterline

He plays the trumpet, has a doctorate in invertebrate zoology, and has climbed Longs Peak more than 400 times. Known as "Mr. Longs Peak," Dr. Jim Detterline was supervisory climbing ranger on Longs Peak from 1987 to 2009, participating in more than 1,200 rescues in Rocky Mountain National Park during his career—including one that earned him the Valor Award of the Department of the Interior during the summer of 1995. Two adults had fallen into the frigid waters of the Roaring River and were clinging to a rock 15 feet above 75-foot-high Horseshoe Falls. While the technical rescue was being set up, Detterline waded into the water to stabilize the victims when they unexpectedly lunged at him. Detterline held on until the rangers pulled them all to safety. When Detterline retired from the National Park Service in 2009, the Estes Park community recognized him by saying, "If Jim Detterline is on your SAR, [search and rescue], you're as good as home." A native of Pennsylvania coal country, Detterline first summited Longs Peak by the Diamond Route in 1985 and has averaged more than a dozen summits a year since. During those years, Detterline has opened new routes on each of the 14,259-foot mountain's four faces and knows the mountain intimately. One rainy September day in 1990, three men in their 80s wandered into the Longs Peak Ranger Station, and Detterline met Clarin "Zumie" Zumwalt, Dr. Hull Cook, and Everett "Ev" Long—Boulder Field Inn guides from the mid-1930s. Their meeting inspired Jim to organize Longs Peak reunions in 1991 and 1993, as well as a Longs Peak reunion in 2015. (Courtesy of Rocky Mountain National Park Archives.)

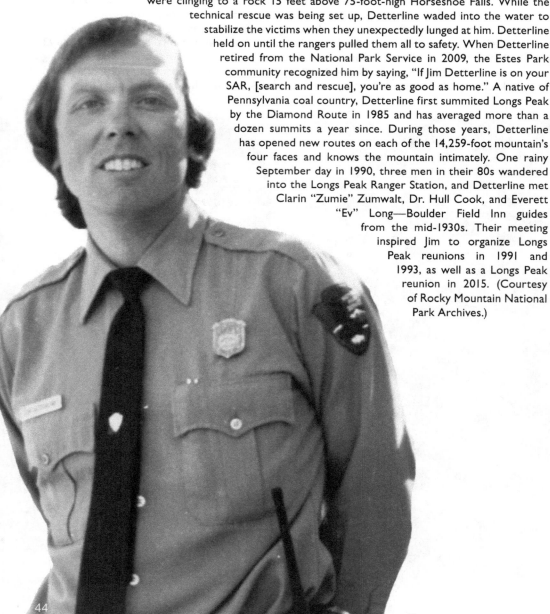

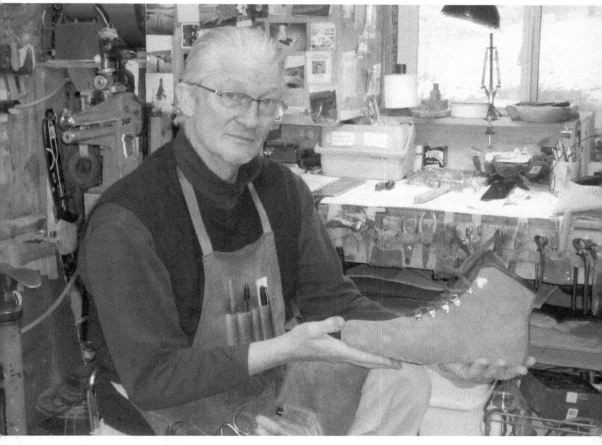

Bootmaker John Calden

Customers are his sales team. Wrote one, "They have given me happy feet on every hike. I've hiked up at least 410 peaks over 13,000 feet, all in Calden boots." In his one-man shop in the lower level of his home, bootmaker John Calden makes custom-fitted boots from high-quality, full-grain leather for hikers and cross-country skiers from across the country. Sporting trademark purple laces, his boots are so well-crafted and in such high demand that he has orders for 18 months out. Calden specializes in the difficult-to-fit: the size 20 feet, the mountaineer who lost his toes to frostbite, and the hiker whose feet are rubbed raw by off-the-shelf boots. A native of Oakland, California, Calden took a leather craft course at Laney Community College and began repairing boots at a mountaineering store in Berkeley. When he visited Estes Park in 1972, Calden met the high priest of boot repair, Steve Komito, who offered him a job in his shop. Calden lived in Komito's basement, met climbers from all over the world, and repaired boots. Four years later, he learned custom bootmaking from Bob Grabbe in Frisco, Colorado, and began making boots in a rented space in Komito's boot shop. Calden's experience in boot repair was his best teacher, showing him what most often failed in hiking boots and how to fix those failures in his own boot design. He hit his stride in bootmaking when he married his wife, Diane, and rented an old shed in Allenspark from his friend Warren Donahue. With no phone and only his dog Huckleberry and his children Gracie, Walker, and Isaac for company, Calden focused on creating and perfecting his boots, making four to seven pairs a month and coming up with the Calden Fit System. Today, Calden has a loyal following of satisfied customers who advertise his quality boots through word-of-mouth and those purple laces. As one customer said, "I love, love, love my boots. They are truly wonderful." (Courtesy of Steve Mitchell.)

Climber, Author, and Mother Lisa Foster

The moment Lisa Foster stood on top of Longs Peak for the first time in the summer of 1987, she thought, "This is what I want. This is the life I want right here." Born in Montana and raised in North Dakota, Foster came to Estes Park the summer after her first year of college and fell in love with the mountain and Rocky Mountain National Park. After Foster graduated from the University of North Dakota in 1990 with a degree in journalism, she made Estes Park her home. When she summited Longs Peak on December 8, 2011, Foster became the first woman to climb Longs Peak every month of the year. In August 2015, Foster climbed Longs Peak for the 73rd time by 17 different routes, breaking the female ascent record held by Ruth Ewald Gay, who climbed Longs Peak for the last time with Jean Weaver in July 1981. "Anything I do, I stand on their shoulders," Foster said. The extremes of Longs Peak prepared Lisa for her climbs of the highest points in North America (Denali at 20,320 feet) and South America (Aconcagua at 22,841 feet). Foster began volunteering at Rocky Mountain National Park in 1994 and worked as a biological science technician from 2003 to 2007, taking nitrogen samples in the park's far reaches for the National Atmospheric Deposition Program. In 2005, Foster published *Rocky Mountain National Park: The Complete Hiking Guide*, recognized as the bible for the outdoor enthusiast. She spent 15 years hiking and climbing to every named destination within the borders of the park and another two years in front of the computer writing it down. Foster credits her husband, Alex Kostadinov, and her dozens of hiking companions for the guide's success. Foster's approach to climbing has become more cautious with the birth of her daughter six years ago. She incorporates her passion for the outdoors with her parenting, strapping baby Ellie Kostadinov on her back and hitting the trail. At six years and two months old, Ellie became one of the youngest females to climb Longs Peak under her own power. Foster is currently a guide for Dovetail Mountaineering and head guide for Kirk's Mountain Adventures in Estes Park. (Courtesy of Lisa Foster.)

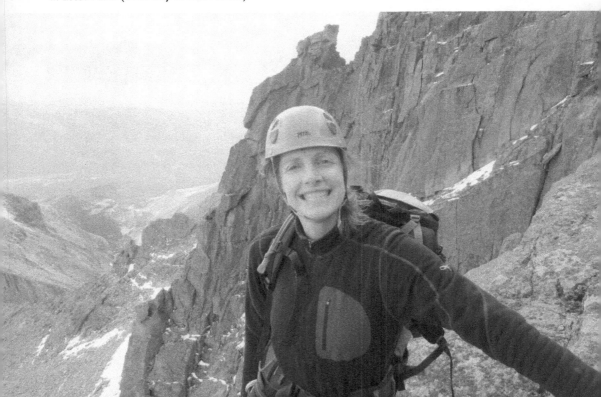

CHAPTER FOUR

Inspired by Rocky

The Rocky Mountains inspire artists to explore, live, and create. Isabella Bird, one of the world's first female travel writers, wrote expansively about the Rockies after Rocky Mountain Jim guided her to the top of Longs Peak in 1873. Richard Tallant was already an accomplished painter when he moved to Estes Park in 1898. His worldwide reputation attracted a colony of artists to Estes Park eager to paint the Rocky Mountains. In 1905, Fred Clatworthy bought two lots in downtown Estes Park for his photography studio and, for the next 50 years, chronicled through pictures the early history of Estes Park, Rocky Mountain National Park, and the YMCA of the Rockies. Journalist William Allen White, known as the "Sage of Emporia," bought his cabin in Moraine Park in 1912 and returned to his refuge almost every summer to think, write books, and raise his two children with his wife, Sallie. Painter Dave Stirling delighted visitors at his studio, Bugscuffle Ranch. Some say he produced 30,000 paintings of the Rockies during his more than six decades in Estes Park. Writer Clem Yore settled in Estes Park in 1915, and his poetry reflected the majesty of the Rockies. At his downtown gallery, Lyman Byxbe created affordable etchings of mountains, trees, and landscapes for sale. Alfred Wands moved to Estes Park in 1943 and was known as the "dean of outdoor landscapes." His son Robert followed in his footsteps, becoming an accomplished artist and opening the Wands Gallery off High Drive every summer. Greig Steiner arrived in Estes Park in 1959 to direct plays for the Dark Horse Theater and never left, painting with Dave Stirling and eventually opening his own art studio. Art teacher Glenna Dannels opened the Spectrum in 1969, which was no ordinary downtown shop but a gallery, studio, and school wrapped into one. Musician Dick Orleans settled in Estes Park in the early 1980s and played at local venues, but it was wildlife photography that inspired him. For 20 years, award-winning filmmaker Nick Molle hiked and filmed in Rocky Mountain National Park, producing nature films that appear on PBS. "Rocky Mountain High" is one of the most requested songs when singer-songwriter Cowboy Brad Fitch walks onto stage. Today, photographers James Frank and Erik Stensland capture the beauty that is Rocky Mountain National Park and share it with the world.

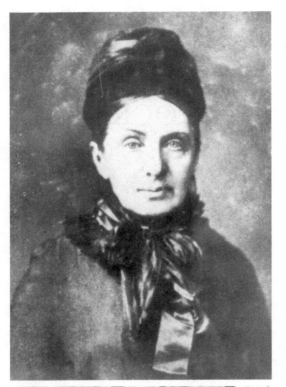

Travel Writer Isabella Bird (1831–1904)
A sickly English woman in her 40s, Isabella Bird traveled to the Rocky Mountains in 1873, rode her borrowed horse "Birdie" through thigh-deep snow, and climbed the daunting 14,259-foot Longs Peak with the help of a one-eyed desperado and poet named "Rocky Mountain Jim" Nugent. Bird described Jim as "a man any woman might love but no sane woman would marry." Bird wrote of her adventures in letters to her sister Hennie, which later became the popular travelogue *A Lady's Life in the Rocky Mountains*. Her book sold to a prim, Victorian world eager to hear about her adventures. (Courtesy of Estes Park Museum.)

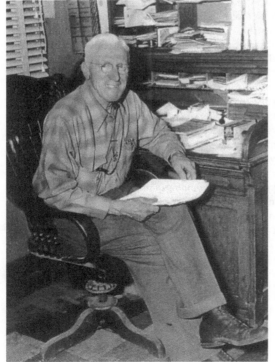

Photographer Fred Payne Clatworthy (1875–1953)
In 1898, Fred Payne Clatworthy pedaled the West on a bicycle and photographed his adventures, but it was Estes Park that captured the budding photographer's heart. In 1905, Clatworthy borrowed money to purchase two lots in downtown Estes Park for $100, constructing a building for his photography gallery that he called Ye Lyttle Shop. For the next 50 years, using the natural color film process called autochrome, the world-famous photographer published his images in *National Geographic* and chronicled through pictures the early history of Estes Park, Rocky Mountain National Park, and the YMCA of the Rockies. (Courtesy of YMCA of the Rockies, Lula W. Dorsey Museum.)

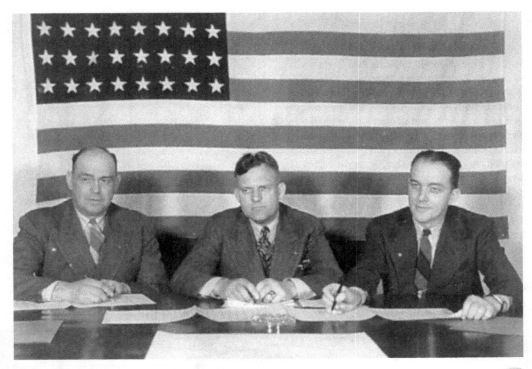

Artist Richard H. Tallant (1853–1934)

Estes Park residents called Richard H. Tallant "Judge," because he served as justice of the peace. But he was also an accomplished Colorado painter and illustrator known for his exhibitions, calendars, magazine covers, and original landscapes. Born in Zanesville, Ohio, Tallant (seated on the left) prospected and painted in Colorado mining camps in the 1880s before Shep Husted built him a cabin for $100 on his homestead claim at the north end of Devils Gulch in 1898. Tallant moved his studio downtown in 1908. His worldwide reputation attracted a colony of artists to Estes Park eager to paint the Rocky Mountains. (Courtesy of Estes Park Museum.)

Novelist and Poet Clement "Clem" Yore (1875–1936)

Writer Clement "Clem" Yore honeymooned in Estes Park with his second wife, Alberta Yore, and made it their home. During Clem's writing career, he wrote 20 mystery, detective, and western novels, two books of verse, and more than 600 short stories and 300 poems. Born in St. Louis, Clem left home at 12, joined the Texas Rangers, prospected in Creede, Colorado, wrote about the Klondike Gold Rush, fought in the Spanish-American War, and was editor of the *Chicago American*. But once in Estes Park, Clem's writing turned to the mountains. The state legislature adopted his lyrical poem "Colorado" as Colorado's official poem. (Courtesy of Estes Park Museum.)

"Youngest of the Old Masters" Dave Stirling (1887–1971)

Evenings after a day of painting, artist Dave Stirling often dropped by Estes Park night spots to play the piano, sing, and spin tales about life in the mountains. The next day, people stopped at his studio Bugscuffle Ranch, rang the cowbell tied to a tree limb, and bought a painting. If they were fortunate, Stirling—dressed in a cowboy hat, bandanna, and striped pants—talked about his oil paintings. Stirling said, "Everyone goes away smarter than when they stumbled into the joint." Born in Corydon, Iowa, Stirling attended the Cummings Art School in Des Moines, Iowa, and the Academy of Fine Arts in Chicago before arriving in Estes Park in 1915. Stirling worked exclusively in oils, focusing on mountain landscapes and vivid aspen and emphasizing color over form. Governor Love called Stirling the "Youngest of the Old Masters." (Both, courtesy of Estes Park Museum.)

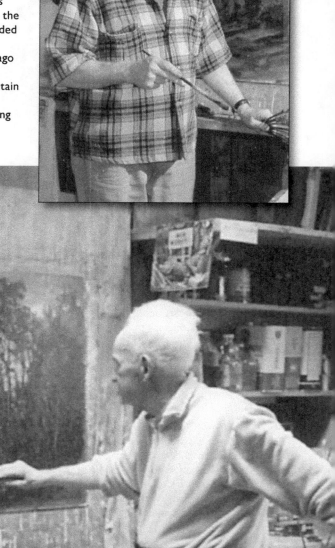

"Sage of Emporia" William Allen White (1868–1944)

Before he became a nationally respected journalist from Emporia, Kansas, William Allen White brought his new bride, Sallie White, to Estes Park for a honeymoon in 1893. In 1912, they bought a cabin in Moraine Park, which is known today as the William Allen White cabin. Though the Whites did not hike, hunt, or fish, the cabin was a perfect place to reflect, write books, and raise their two children, Bill and Mary White. From the front steps of the cabin, White blew a cow horn at mealtime, and the children would come running. (Courtesy of Rocky Mountain National Park Archives.)

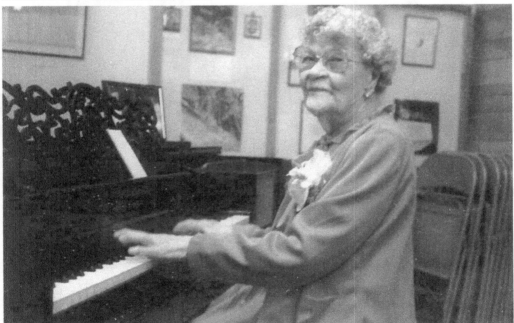

Piano Player Hazel Baldwin (1894–1992)

At the age of 20, Hazel Baldwin came to Estes Park in 1914 to play background piano music for the silent movies at the Park Theater. Baldwin was a gifted musician who began teaching the piano at age 14. She married her husband, Roy, in 1918 and settled into a house on West Riverside Drive, where she lived for 72 years. Baldwin played for school programs and theater productions as well as chamber music at local hotels. She was choir director at the Community Church of the Rockies and played the piano for the old-timers at the nursing home. Baldwin Park is named in Hazel and Roy's memory. (Courtesy of Estes Park Museum.)

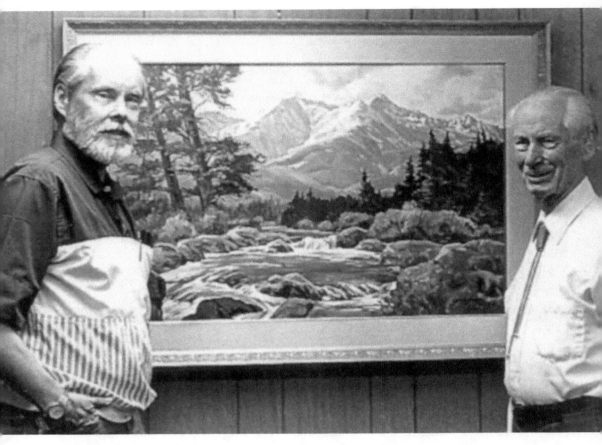

Artists Alfred "Al" (1904–1998) and Robert Wands
Often spotted painting along the roads and trails of Estes Park, artist Alfred "Al" Wands worked in oil, watercolor, and prints and was known as "the dean of Colorado landscapes." Born in Cleveland, Ohio, Al graduated from the Cleveland Art Institute and studied painting in Europe before moving to Denver in 1930 to become the head of the art department at the Colorado Women's College. Al moved to Estes Park in 1943 and became camp artist at the YMCA. In 1947, Al retired from academic teaching to make his name as a painter. His son Robert grew up sketching and, at the age of 12, was helping Al with his classes at the YMCA. Robert was awakened to abstract art when he attended the University of Denver, where he earned a BFA and MFA. From 1963 to 1996, Robert taught in the art department at Colorado State University–Pueblo and then opened a gallery in the Courtyard Shops. Robert and his father painted together and presented father-and-son shows. Today, Robert winters in Pueblo and opens his gallery on High Drive from June through September. (Courtesy of Estes Park Museum.)

Artist Lyman Byxbe (1886–1980) and his Etchings

Award-winning artist Lyman Byxbe created shimmering etchings of mountains, trees, and landscapes that almost anyone could afford. Born in Pittsfield, Illinois, Byxbe worked as a commercial artist in Omaha, Nebraska, where he began to study etching with architect Mark Levins. His reputation grew as he worked for the Federal Art Project in the 1930s, was accepted into the Chicago Society of Etchers in 1935, and had a one-man show at the Smithsonian in 1937. At the age of 53, Byxbe packed his press and moved permanently to Estes Park with his wife, Geneva. They opened a shop on Elkhorn Avenue, where they sold drypoints, etchings, engravings, and aquatints, the latter of which uses a technique that produces a print with the look of a watercolor. (Left, courtesy of Estes Park Museum; below, courtesy of Jack Melton.)

Gentle Spirit Herb Thomson (1926–2001)

A gentle spirit who often signed his vibrant watercolor landscapes with scripture verse, artist Herb Thomson was also a dedicated teacher. Born in Leadville, Herb earned a Bachelor of Fine Arts and a teaching degree from Denver University after serving in the Navy during World War II. While teaching middle school in Pueblo, Herb worked summers as an Elkhorn Lodge bellhop. In 1962, Herb and his wife Rosa Thomson moved to Estes Park where Herb taught fifth grade art in the Estes Park schools and, beginning in 1982, became camp artist at the YMCA of the Rockies. For 25 years, Herb honored a "dedicated" Estes Park teacher with the Tommy Thomson Memorial Teaching Award. At his "Creative Recovery" programs, Herb talked about life and hope and spirituality while creating a watercolor landscape. A mirror placed overhead allowed people to watch every stroke. (Both, courtesy of Rosa Thomson.)

Nature Lovers Ted (1905–2001) and Lois Matthews (1918–2000)

Not only were Ted and Lois Matthews longtime shop owners in Estes Park, they were also professional wildlife photographers whose images appeared in *Reader's Digest*, *National Geographic*, and *Petersen's Field Guide to Birds*. After Ted served in the Army in World War II, he returned to Estes Park and ran the Park Shoe Shop with Lois until 1951, when they bought Gift Haven and operated it until they retired in 1971. The couple's passion for taking pictures of flowers and birds took them across the country as wildlife photographers. Ted and Lois were both avid mountain climbers and skiers, and Ted was one of the few people to climb Longs Peak every month of the year. Ted's ancestors homesteaded near Pole Hill in the late 1800s, and as a child, he remembered attending Rocky Mountain National Park's dedication in 1915. (Both, courtesy of Robert J. and Theodora A. Haines.)

Artist, Dancer, and Stage Director Greig Steiner
While serving in the Army in Korea, Greig Steiner never traveled without his tap shoes. Born in Los Angeles in 1934, Steiner graduated from the Pasadena Playhouse College of Theater Arts in 1959 and worked on more than 350 shows in California and Washington, designing, building and painting sets as well as producing, acting, directing, and dancing. Steiner became art and technical director for the Dark Horse Theater in Estes Park in 1959, where he produced more than 20 shows during four summers and met his wife, Ann Steiner. In 1962, Steiner switched to easel painting with artist Dave Stirling, who he worked with until 1968. In 1973–1974, Ann and Greig designed and built the Courtyard Shops to contain the Greig Steiner Gallery. Four years later, they expanded the complex to contain 16 shops, the Courtyard Tavern, and the Gazebo Restaurant. Steiner works in oil, sculpts in bronze, and cold casts marble, terracotta, and porcelain. Though his work has been shown in galleries from New York to California, he still acts as stage, art, and tech director for the Fine Arts Guild of the Rockies, most recently designing and building the set for *South Pacific* in 2015. (Courtesy of Greig Steiner.)

Artist Glenna Dannels and the Spectrum

The Spectrum in downtown Estes Park was a gallery, studio, and school wrapped into one. It had a 1960s vibe, displaying ceramics, jewelry, leather craft, prints, oils, and photography from Colorado artists—many just starting out. It was a welcome place to grab a mug of coffee and chat about art. After starting the art program in Estes Park schools, Glenna Dannels opened the Spectrum in July 1969 with 14 artists and operated it on a consignment basis, taking one-third commission to cover overhead. Dannels taught guitar, drawing, jewelry, ceramics, weaving, leather craft, and silk-screening. At its peak, the shop featured more than 400 Colorado artists. "The kids called it a commune, with me paying the bills," Dannels said. She was married to Mayor Bernie Dannels. (Both, courtesy of Glenna Dannels.)

Musician and Photographer Dick Orleans (1950–2014)
"He's the guy who woke up every morning, looked at the mountains, and said, 'this is where I live,' " said Kind Coffee owner Amy Hamrick of her uncle Dick Orleans. The longtime Estes Park musician and wildlife photographer died of a sudden heart attack on May 12, 2014. But it is for a life well-lived that locals remember Orleans. Born in New Jersey, Orleans grew up a musician and toured the country in a white van he called the Big White Whale. When he arrived in Estes Park in the early 1980s, he fell in love with the mountains and settled down. A self-taught guitar player, Orleans played many venues in town, preferring to collaborate rather than compete. Through Friends of Folk, Orleans encouraged local musicians to perform at open-mic sessions and always had time to talk about music and mentor up-and-coming performers in town. He formed the Elktones with Brad Fitch, Brad Doggett, and Mark Rashid in 1996 and, with Fitch, coproduced the group's first album in his recording studio. In recent years, Orleans turned his creative energy to wildlife photography. While music meant late nights, photography got him outside in the early morning and late afternoon. "It took him back to why he lived here," Hamrick said. Orleans waited hours for a shot of an elusive black fox hiding behind a rock or an osprey carrying a fish. A health-conscious vegetarian, Orleans's sudden death shocked his friends. But they all agreed that he died doing what he loved to do. (Courtesy of Amy Hamrick.)

"Cowboy" Brad Fitch
A spitting image of John Denver, singer-songwriter "Cowboy" Brad Fitch plays original folk music, classic cowboy tunes, and Denver covers. A former Coast Guard officer and ranger at Rocky Mountain National Park, Fitch plays eight instruments and has performed professionally since age 15. He has recorded 16 albums and plays 300 dates a year but still performs benefits, the most popular of which are John Denver tribute concerts. His performances support the Rocky Mountain Nature Association, the Estes Park Lions Club, Cancer Center of Arizona, and the Estes Park Cultural Arts Council. Recently, Fitch wrote "Rocky," the official song for the Rocky Mountain National Park centennial. (Courtesy of Brad Fitch.)

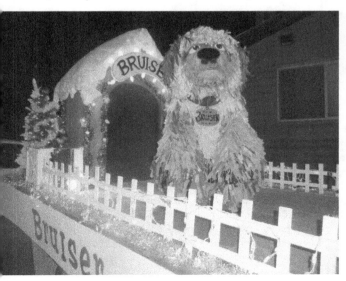

Bob Aiken as Bruiser the Dog
Children's eyes light up when the big, shaggy dog named Bruiser appears. Inside the dog suit is puppeteer Bob Aiken, who first created Bruiser out of scraps of knit fabric in 1983 for a puppet show. "Bruiser makes the scene and there's great fun. It cracks people up," Aiken said. Bruiser has appeared at fairs across the country and is a regular on Boulder's Pearl Street Mall. Last summer, Bob finished his sixth version of Bruiser, adding a new head, new feet, and fresh cloth fur. Bruiser appeared at the Estes Park Catch the Glow Christmas Parade and the Duck Race. (Courtesy of Steve Mitchell.)

Photographer James Frank

James Frank takes pictures so he can "bring a little light into a person's day." For more than 36 years, Frank has lived near Rocky Mountain National Park and photographed its natural beauty. A native of Medina, Ohio, he graduated from Doane College and moved to Estes Park in 1978. Frank licensed his first postcard in 1979 and established First Light Publishing in 1987 to produce and sell his line of postcards. His licensed images have appeared in books, magazines, ads, and on the Internet, with commercial credits including DuPont, L.L. Bean, American Express, and Northwest Airlines. His fine-art photographs have been published worldwide in numerous books and magazines, including a print as a gift to the emperor and empress of Japan. In addition, Frank has published several books that feature his photography, including *Magic in the Mountains: Estes Park, Colorado, James Frank's Colorado, A Portrait of Rocky Mountain National Park*, and *A Portrait of Pikes Peak Country*. Today, Frank focuses on producing fine-art prints for the Aspen and Evergreen, a gallery he owns with his wife, Tamara Jarolimek. (Courtesy and copyright of James Frank.)

Nick Molle Films Rocky

Nick Molle had seemingly tried it all—acting, playing music, and test-driving BMWs—when the Rocky Mountains sparked his passion for making movies, especially movies about the mountains and wildlife of Rocky Mountain National Park. A native of Mohopac, New York, Molle and his wife, Mary Beth, moved to Estes Park in 1991 with the dream of starting a film production company. Molle bought Estes Park TV Channel 8 and began making films about the outdoor adventures, wildlife, and area history found in the Estes Valley. Recently, features titled *Birds Without Borders*, *Real Rocky*, and *Rivers Without Borders* have attracted national attention on PBS. A self-described "adventure junkie," Molle has also produced films in Alaska, Australia, and Costa Rica. But he returned to his backyard of Rocky Mountain National Park to film *The Living Dream: 100 Years of Rocky Mountain National Park* in celebration of the Park's centennial. (Courtesy of Nick Molle.)

Landscape Photographer Erik Stensland

Early mornings before sunrise often find landscape photographer Erik Stensland hiking to a remote lake or peak in Rocky Mountain National Park. Frequently, he will return with a stunning image to display in his gallery *Images of RMNP*. After graduating from Bethany College, Stensland worked for nongovernmental organizations in the Balkans assisting local churches and agencies. But after 12 years, Stensland moved to Allenspark with his wife, Joanna, in 2004 and decided to become a photographer. His first step was to buy the *Photography for Dummies* book. Within the year, Stensland was selling photographs, and in three years, he opened his gallery. "You get to encounter yourself," Stensland said of exploring the park. "Without solitude, we live on the surface of our lives." Stensland published his coffee table book *Wild Light: A Celebration of Rocky Mountain National Park* in conjunction with the park's centennial celebration. It recently won the Gold Medal in the Nature/Environment category at the 2015 Benjamin Franklin Book Awards. Stensland lives in Estes Park with his wife, Joanna, and son Luke. (Courtesy of Erik Stensland.)

CHAPTER FIVE

Entrepreneurial Spirit

When conducting business in a tourist community, an entrepreneur must learn to adapt or fail. When the snow piled on the streets in the early 1900s, Sam Service welcomed Estes Park's male residents to warm themselves around his store's potbellied stove. George "Pop" Watson hauled ice throughout the Estes Park Valley with his team of horses while his son Bill trucked coal and wood. In 1908, J. Edward Macdonald opened a general store on Elkhorn Avenue with a small corner devoted to books. Today, in the same location, Paula Steige continues the family tradition with the independent Macdonald's Book Shop. For 50 years, grocer Ron Brodie extended a line of credit to local families in the winter until tourists returned the following season. The locals ate at the Old Plantation Restaurant because of the Burgess Brothers, with Bill out front and Bob in the kitchen. Lowell Slack's Taffy Shop satisfied the sweet tooth, its salt water taffy so popular the recipe was kept under lock and key. O.M. Nagl bought a bar in downtown Estes Park in 1945 and renamed it the Wheel because it was a hub of activity. Across the street, "Pep" Petrocine's Western Brands sold cowboy boots, jeans, and hats, and printed a catalog in 1949 to start a successful international mail-order business. Pep later expanded into outdoor gear and computers. When Harvey Coleman farmed in Iowa, he watched kids line up to ride his son Gary's go-kart. In 1959, Harvey opened Ride-A-Kart, which is still entertaining kids today. Kings Casuals was Mary Whitaker's distinctive woman's clothing store, a business she promoted with weekly newspaper columns. Phil and Chris Switzer founded the first Colorado alpaca farm in 1985 and today are experts on the care and breeding of alpacas and paco-vicuñas. The Webermeier Family has been welcoming visitors to Estes Park since the 1950s—first at Deer Ridge Chalet, then at National Park Village (North), and today at National Park Village South. Since 1976, Roger Thorp's "gentle architecture" has welcomed those who have visited Estes Park, from the Dannels Fire Station and the Estes Valley Library to Barlow Plaza and the Estes Park Conference Center. Olga Ortega Rojas moved to Estes Park from Mexico with her extended family in 1992. Seven years ago, she realized her dream and opened Mountain Home Café, a local favorite. Working in coffee shops in college, Amy Hamrick now owns Kind Coffee and is a business leader downtown. All have that inspiring entrepreneurial spirit.

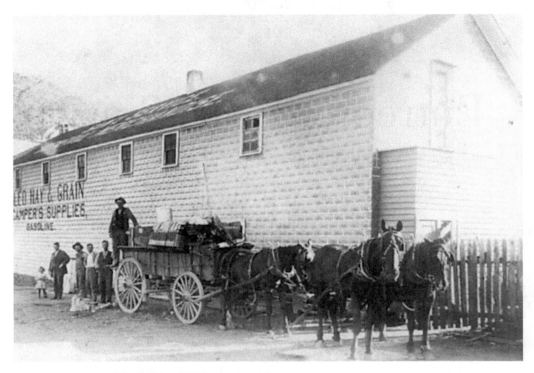

Sam Service (1860–1937) and his Store

When snow piled on Elkhorn Avenue in the early 1900s, Estes Park's male residents warmed themselves around the potbellied stove at the Sam Service Store. After selling his quarry and store in Lyons, Irish native Sam Service and his wife, Sadie Service, purchased Billy Parkes's grocery store. When business outgrew the small building, he constructed a new building in the fall of 1905 with advertising on the roof. Service kept expanding his business until he retired in 1928, building a log home with a picket fence next door as well as a bakery, warehouse, storage building, and a filling station down the street. (Courtesy of Estes Park Museum.)

Everett "Granny" May (1896–1968)

As a youth, Everett May was responsible and "old" for his years, so people teased him and called him "Granny." Born in Minot, North Dakota, Granny attended school in Lyons and served in the Navy during World War I. Afterward, he moved to Estes Park and operated the Cheley Camp stables for 30 years. He married Legora May, and they lived on the May Ranch, which stretched from Lyons toward Estes Park. In 1958, he sold about 1,300 acres, which became Pinewood Springs. He served as deputy sheriff in Estes Park from 1953 to 1958. The Stanley Park Fairgrounds arena was named in his honor. (Courtesy of Estes Park Museum.)

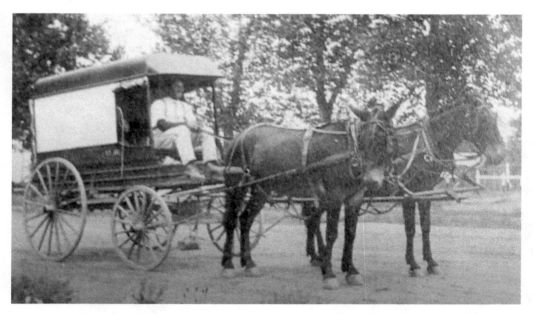

George "Pop" and Bill Watson and the Freight Business
When George "Pop" Watson whistled, his horses Bess and Cricket dragged 400-pound ice blocks from Bear Lake and Estes Park ponds. Then, Pop hauled it to the icehouse at the Stanley Hotel and other locations. Pop arrived in Estes Park in 1918 and worked for Frank Cheley, cutting and hauling logs that became the Cheley Lodge. As an entrepreneur and civic leader (town board member), Pop put people to work during the lean winter months hauling timber, ice, and coal. When he moved from horses to trucks, his 13-year-old son Bill got behind the wheel. He hauled logs to the mine in Erie and returned with coal. Bill soon took over the freight business and got involved in excavation, building Marys Lake Campground in 1968. Watson Moving and Storage is still family-operated by Pop's great-grandson. (Both, courtesy of the Watson family.)

H.D. Dannels and Son

The quality of workmanship is apparent in the hundreds of homes and dozens of businesses built by H.D. Dannels and Sons. In the 1920s, Henry Dannels ran an Allenspark sawmill and later helped build the Crags and Stanley Hotels. In 1936, Henry and Josephine Dannels moved to Estes Park, where Henry served 20 years on the town board (1952–1972). For their son Bernie's high school graduation present, his parents gave him a carpenter starter kit and made him a business partner. Once Henry stepped off the board, Bernie stepped on, serving 12 years on the board and 12 years as the "Plaid Mayor." Bernie was involved in the recoveries after the Big Thompson and Lawn Lake floods, the Estes Park Urban Renewal Authority, and the Marys Lake Water Treatment Plant. The Dannels Fire Station was named in his honor for his many years of service in the Estes Park Volunteer Fire Department. Bernie was married to Glenna Dannels. (Both, courtesy of Glenna Dannels.)

NC 46438

A CORDIAL INVITATION IS EXTENDED 1906 OUR PRESIDENT TO SPEND A WELL — EARNED VACATION AT ESTES PARK COLORADO

SCENIC AIRWAYS

Ron Brodie (1908–1987) and Brodie's Supermarket

If a local family could not afford food during Estes Park's lean winter months, Brodie's Supermarket extended a line of credit until tourists returned in the summer and families could pay their bills. Owner Ron Brodie (at left above) bought Boyd's Market in 1936, and when he opened at a new location on Elkhorn Avenue in 1957, he advertised that it was the "most modern grocery store in Colorado." It had a butcher counter, an in-house bakery with four ovens, and a home delivery service. Longtime locals remember feeding the ducks in Brodie's parking lot and watching children receive pumpkins at Halloween. Brodie was civic-minded, serving on the town board for 32 years (11 years as mayor), volunteering for 30 years on the Estes Park Volunteer Fire Department, and serving on the Light and Power Committee and the Estes Park Sanitation Board. (Above, courtesy of RMNP Archives; left, courtesy of YMCA of the Rockies, Lula W. Dorsey Museum.)

Lowell Slack (1903–1994), the Igels, and the Taffy Shop

Five generations have stopped at the Taffy Shop to buy the delicious candy that is created from scratch every day. It is prepared on-site and then pulled, cut, and wrapped in a Model K Kiss Wrapper manufactured in 1947. Lowell Slack (top) moved to Estes Park in 1934 and sold his taffy in the curio shop in the Pueblo Building, before moving to his current location a few years later. In 2014, Lowell's wife, Lavonna, sold the Taffy Shop to the Mark and Kelly Igel family, only after they agreed to maintain the shop's standards and recipes, which were kept in a safe deposit box. Today, Mark (bottom) estimates that the shop makes up to 35,000 pieces of taffy every summer day to serve people lined out the door. The seven Igel children plan to work in the Taffy Shop, which is celebrating its 81st anniversary. (Top, courtesy of Robert J. and Theodora A. Haines; bottom, courtesy of Steve Mitchell.)

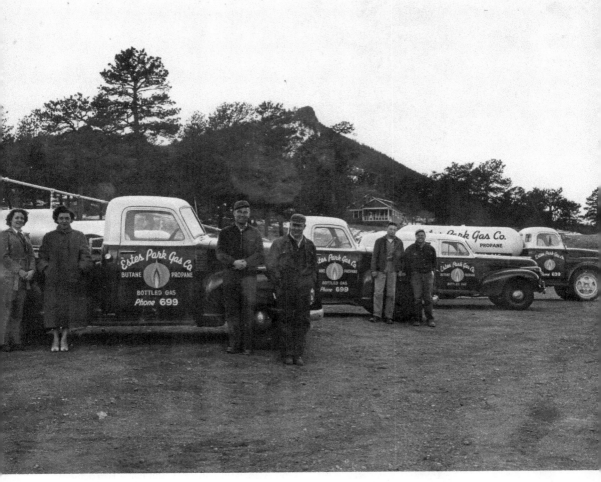

Clarence Graves (1892–1980) and LP Gas Business

When Clarence and Lois Graves returned to Estes Park in 1934 for their daughter Margaret's health, Clarence ran the Red and White Grocery Store for three years before going into the hardware business. In 1941, Clarence sold the hardware store and went into the LP gas business with his son Barney. His gas company was a place to work in the off-season for folks with seasonal businesses, like Bob Burgess at the Plantation and Andy Anderson at Anderson's Wonderview. Clarence's store on Elkhorn Avenue sold gas, stoves, tile, linoleum, tackle, pots, pans, and household goods. In 1942, Clarence joined the town board and served until 1952, when he became mayor for 16 years. During his administration, the town became a member of the Northern Colorado Water Conservancy District and was a charter member of the Six Cities Water Committee, which developed the Windy Gap Water Project. (Courtesy of Estes Park Museum.)

Norman "Pep" Petrocine (1921–2001), Son Ernie Petrocine, and Western Brands Friendly, community-minded Norman "Pep" Petrocine (top) welcomed new business owners to Estes Park with a handshake. A B-17 pilot who flew 35 missions over Europe, Pep—in partnership with Jack Cheley and Ernie Altick— bought Gooch Dry Goods in September 1947. He renamed it Western Brands, welcomed Cheley campers to buy cowboy boots, jeans, and hats, and printed the first international mail-order catalog in 1949. Workers in the back room sewed "Play Togs" and "Diaper Duds" to fill the orders. Pep opened Outdoor World in 1967 in anticipation of the outdoor apparel explosion and started a computer store in 1982. A Rotarian for 50 years, Pep was chamber of commerce president, served on the planning commission, and was president of the Estes Park Men's Golf Association. In 1993, son Ernie Petrocine (bottom) took over management of the stores that remain mainstays on Elkhorn Avenue. (Top, courtesy of Estes Park Museum; bottom, courtesy of Steve Mitchell.)

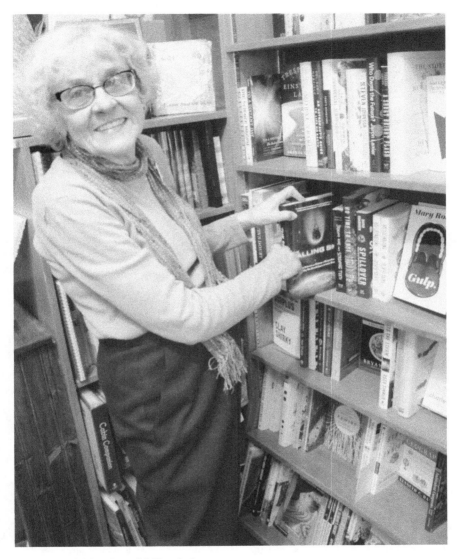

Paula Steige and Macdonald Bookshop

Imagine a cozy living room where books are found in every nook and cranny. For more than 100 years and three generations, the Macdonald Bookshop has thrived in downtown Estes Park. In 1908, J. Edward Macdonald opened a general store on Elkhorn Avenue that sold hardware, groceries, paint, and sundries—with a small corner devoted to books. When Macdonald retired in 1928, he helped his wife, Jessica, open a bookstore in the parlor of their log cabin home next door. It sold books, magazines, candy, cigars, and office and school supplies. Authors Marie Sandoz and William Allen White visited the shop. Over the years, the shop took over the family home, and daughter Louise helped during the summers with her two children, Paula and Mark. Paula Steige has guided the bookshop since 1971, selling books and placing an emphasis on friendly, hometown service. She brings in writers, works closely with local authors, and is a big supporter of the Estes Valley Library Foundation annual dinner. During the 1982 Lawn Lake Flood, the shop was inundated, but with the help of 80 volunteers, Steige repaired and expanded the shop into more of the original home. Today, the shop sells more than 30,000 books a year thanks to Steige's devotion to genuine, small-town service. (Courtesy of Heidi Wagner.)

The Burgess Brothers and the Plantation Restaurant

William "Bill" Burgess worked the dining room and the upstairs tavern at the Old Plantation while his younger brother Robert "Bob" Burgess ran the kitchen and talked to Chuck Benson on KSIR Radio every summer about the latest entrees: rainbow trout, sizzling steak, Yankee pot roast, and the pies (oh, the pies). Family-owned since 1931, the restaurant hit its stride when Bill and Bob's mother, Thelma Burgess, married C. Warren "Chappy" Chapman in 1932 and took over the running of the restaurant in 1934, while Bill and Bob worked odd jobs at the eatery. After Bill and Bob graduated from Estes Park High School and served during World War II (Bill in the Army Air Corps and Bob in the Navy), they were in Denver University's first graduating class of the School of Hotel and Restaurant Management. When Chappy died in 1956, Bill and his wife, Harriet, returned from New Mexico to help Bob; his wife, Janet; and Thelma run the Plantation. The brothers remodeled the restaurant's interior in 1969 and built a stairway to the Coat of Arms Tavern. Harriet did the bookkeeping. In 1979, Bill and Harriett sold their share to Bob and Janet, who ran the Plantation until it closed in 1992. Always civic-minded, Bill served on the Estes Park Sanitation Board and School Board and was a volunteer deputy sheriff, while Bob served on the town board, was treasurer for the chamber of commerce, and was a deputy sheriff of Larimer County. Bill and Bob also developed the Lone Pine Acres subdivision. Bob (left) and Bill Burgess are pictured with their wives Janet and Harriet. (Courtesy of Debbie Burgess Richardson.)

The Nagls and the Wheel Bar

"Open Every Day but Xmas since 1945" declares the sign on the door of the Wheel Bar. O.M. "Mike" (above) and Lee Nagl (left) purchased the Estes Park Beer Parlor in 1945 and chose the name "Wheel" in a "name-the-bar contest" because it was the hub of the town where locals hung out. The Nagls started long-running traditions, like the Wheel Bar Open Golf Tournament and the March of Dimes Drive run by Lee. After 32 years, Steve and Gay Nagl took over ownership of the bar in 1977, and Steve—with Nicky Kane, Mike McDonald, and Stan Pratt—inspired the Estes Park Duck Race. After the Lawn Lake flood devastated downtown in 1982, the Wheel was the first Elkhorn business to open, offering refuge to shell-shocked businessmen. Ty Nagl continues a third generation of ownership at the Wheel. (Above, courtesy of Estes Park Museum; left, courtesy of Debbie Burgess Richardson.)

Webermeier Family and Deer Ridge Chalet, National Park Village North and South
The Webermeier Family has been welcoming visitors to Estes Park since the 1950s, first at Deer Ridge Chalet in Rocky Mountain National Park, then at National Park Village (North), and today at National Park Village South. John and Pat Webermeier moved to Estes Park in 1957 to join Pat's parents, the Schuberts, in running Deer Ridge Chalet. When the park acquired the property in 1960, the Webermeiers joined the Schuberts in developing National Park Village at the Fall River entrance to the park, with John taking over the property in 1968. It featured a miniature train, viewing tower, stables, hair salon, gift shop, and the Covered Wagon dining room. While running his business, John served three terms on the chamber of commerce board as well as the school board, where he was instrumental in helping pass bond issues to build the new elementary school and high school. In June 1978, John opened the 35,000-square-foot National Park Village South and turned over its operation to his son John "Scott" Webermeier, who had recently graduated from Colorado State University. Scott served as president of the chamber of commerce, as well as on the Park R-3 School Board while he ran National Park Village South with his wife, Katie, who managed the retail clothing and gift store. The Webermeiers sold their business in September 2015. Pictured are Pat and John Webermeier. (Courtesy of Katie Webermeier.)

The Colemans and Ride-A-Kart

Teenagers who grow up in Estes Park work at Olympus Ride-A-Kart or wish they had. The go-karts, bumper boats, miniature golf, and Casey's Train offer family fun while employing 35 local kids a season over the past 15 years. "We teach the kids the value of honesty and hard work," Gary Coleman said. In 1956, while farming near Paton, Iowa, Harvey Coleman watched kids line up to ride his son Gary's homemade go-kart and thought, "I can get out of farming and still make a living." Harvey and his wife, Marcella, opened a dirt go-kart track near the base of Olympus Dam in 1959. Over the years, they upgraded the go-kart track and purchased Casey Martin's Silver Streak train in 1972. Gary and his brother Don took over the operation of Ride-A-Kart more than 20 years ago and welcome back third and fourth generations of families. Pictured above are Don (left) and Gary Coleman. Below are Harvey and Marcella Coleman. (Both, courtesy of Gary Coleman.)

Jerry Brownfield (1908–1983) and Brownfield's Leather Shop

The tireless promoter of an indoor horse arena, Gerald "Jerry" Brownfield often acted as commentator for the Rooftop Rodeo parade. Brownfield and his wife, Vera, moved to Estes Park in 1956 and founded Brownfield's Leather Shop. Brownfield was active in the Estes Park Horse Show and Rodeo Committee for 20 years and helped found the Rooftop Riders. He described himself as "the only drugstore cowboy in Estes Park who doesn't own a drugstore." Brownfield was active in the Estes Park Chamber of Commerce, the Fine Arts Guild, and the Estes Park Rotary Club. This past summer, Brownfield's Leather Shop opened for its 59th straight summer. (Courtesy of Estes Park Museum.)

Mary Whitaker (1924–2002) and Kings Casuals

Kings Casuals was a distinctive woman's clothing store downtown, owned by Mary Whitaker. In her newspaper column *Casually Mary*, she informed customers of her latest sale while entertaining. "When I first heard about [her 40th reunion], I thought about losing 40 pounds, having a face lift and writing Cary Grant to see if he would come with me," Whitaker wrote. After graduating from the University of Minnesota, she was a stewardess for Pan American Airways. She married King Whitaker and, in the late 1950s, moved to Estes Park and opened Kings Casuals. After King died in 1961, Mary continued to run Kings Casuals with style and elegance. (Courtesy of Steve Mitchell.)

Chris and Phil Switzer and Switzer Land Alpaca Farm

Walk to the fence of the Switzer Land Alpaca Farm, and the smart, inquisitive alpacas and paco-vicuñas run close to investigate. Residents of the area since 1967, Chris and Phil Switzer built an earth-sheltered, passive solar house on land they purchased from the Griffith family west of Estes Park in 1979. A year later, they rescued a female llama from the Denver Zoo and fell in love with the gentle animal. Soon, their interest shifted from llamas to alpacas for their natural colors and fiber quality "finer than cashmere." In 1985, the couple founded the first Colorado alpaca farm. Phil traveled throughout North and South America, purchasing and importing animals from select farms with a focus on the paco-vicuña breed. A cross between the domesticated alpaca and the wild vicuña, this creature is known for its fiber's softness, fineness, density, rarity, and color. Today, the Switzers are the originators of most of the North American paco-vicuña herd, with about 35 animals on their farm and 600 across the country. One of the top alpaca experts in the country, Phil concentrates on the breeding side of the business. He is a founding board member of the Alpaca Owners Association and served on the board of directors of the Alpaca Registry Inc. He is currently on the board of the Paco-Vicuñas Association. He is also a fleece judge and one of six trained phenotypic screeners who inspect alpacas for several registries. A weaver since 1971, Chris earned a BFA in weaving from Colorado State University in 1984 and uses alpaca and paco-vicuña fiber to weave, spin, and knit. She contributes articles to llama and alpaca magazines, judges handspun yarns at area events, teaches, and recently published the fourth edition of her book *Spinning Alpaca, Llama, Camel and Paco-Vicuña*. Together, Chris and Phil helped start the Estes Park Wool Market in 1990, with the coordination of Linda Hinze. Chris spearheaded the educational workshops, while Phil shared his alpaca expertise. Chris is also an active member of the local artist's community, founding the Art Center in 1987 with 21 artists. Today, the nonprofit Art Center is thriving with about 40 artists and regular art classes, shows, and exhibits. (Courtesy of Steve Mitchell.)

Olga Ortega de Rojas and Mountain Home Café

Olga Ortega de Rojas smiles at the regulars who sit at a table at the Mountain Home Restaurant, a local favorite for breakfast and lunch. Olga runs the dining area, while her husband, Enrique—who has 20 years of experience—operates the kitchen. Their extended family of nephews, nieces, and cousins cook and wait tables. Olga and Enrique's son and daughter, both born and raised in Estes Park, also work at the restaurant when they are not attending school. The existence of this family-operated restaurant is due to the hard work and perseverance of Olga and Enrique. Coming from large families in Mexico, Enrique, Olga, and several of her brothers arrived in Estes Park in the summer of 1992 looking for work. Faced with the challenges of little English and lack of housing, the family worked countless jobs in restaurants around town to save money. Finally, Olga and Enrique realized their dream and opened Mountain Home Café seven years ago. The business gives back, supporting local organizations like MacGregor Ranch, Rooftop Rodeo, the Duck Race, Taste of Estes, and Relay for Life. The Rojas are also founding members of Estes Park Gives Back. In addition, Olga is involved in the local Latino community, helping form the Cinco de Mayo celebration 15 years ago. Education is important to Olga and Enrique. Four of their extended family members working at the restaurant are attending college, including their son. Those in high school have college plans. "We are humble, proud, and honored to be part of this journey to such a beautiful town," Olga said. "It is a dream come true for both of us." The importance of family makes the Mountain Home Restaurant a success, but it is not without cost. Olga dedicates this tribute to her brother and father, who she lost on their long journey. Pictured are Olga Ortega de Rojas (left) and her extended family. (Courtesy of Olga Ortega de Rojas.)

Amy Hamrick and Kind Coffee

As the morning sun's rays strike Kind Coffee's picture windows, people line up to order coffee, freelancers arrive with laptops, and mothers meet after dropping their children off at school. Amy Hamrick's Kind Coffee is a gathering place with a heart. When floodwaters shut the coffee shop's doors in September 2013, more than 100 people volunteered in the first three days to help. During those three months after the flood, Hamrick worked hard to repair and open her coffee shop. She made best-selling specialty coffee Flood Mud, which poked fun at the flood and helped those desperately in need. Kind Coffee donated 25 percent of Flood Mud sales—$10,000— to the Estes Park Flood Relief Fund. Because of this generous act and many more, the town declared Hamrick the Philanthropic Businessperson of the Year in November 2014. Hamrick first fell in love with Estes Park and the mountains when she visited her uncle Dick Orleans in 1996. After graduating with a degree in Outdoor Education from the University of North Carolina, Hamrick returned and worked at Estes Park Coffee in Ed's Cantina. Soon, people were asking for organic, fair-trade coffee, so Hamrick took over the wholesale operation and renamed it Kind Coffee to better reflect her mission statement: *To promote the sustainability of our environment through the sale of certified organic and fairly traded coffees.* Hamrick moved into her current location in 2004, and Kind Coffee has taken off. Kind Coffee is an active member of 1% for the Planet, an alliance of businesses committed to leveraging their resources to create a better earth. Hamrick and her husband, Dave, who works for the National Forest Service, live and play in Estes Park. (Courtesy of Tony Bielat.)

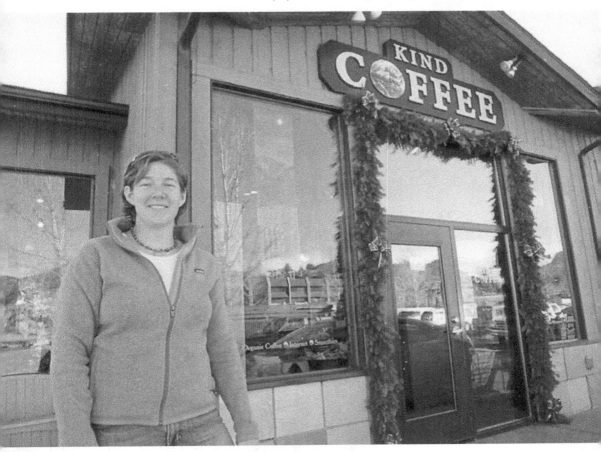

Tamara Jarolimek and the Aspen and Evergreen Gallery

The Aspen and Evergreen Gallery is a perfect fit for passionate art promoter Tamara and her husband, photographer James Frank. "I have a great appreciation for what artists do," Tamara said, noting that most artists need someone with business sense to help. The gallery represents 62 artists, with all but six from the Estes Park area and Colorado. Tamara grew up near Richmond, Virginia, but after college, she packed up her Datsun and headed for Colorado in 1982. She met and married James in 1988 and promoted his successful postcard business First Light Publishing. Together, they opened the Estes Frame and Gallery in 1994 and the first incarnation of the Aspen and Evergreen Gallery in 2002. During that time, they also bought *Estes Park Vacationland* in 2000 and published it for 12 years. As their adopted daughter Claire grew older, they sold the gallery so they would not be locked into set work hours. Today, back with Aspen and Evergreen for a second time, Tamara encourages artists to sell their work. No stranger to community service, Tamara has served on the chamber of commerce board for five years and the Estes Park Urban Renewal Authority board for five years. She and James look forward to helping establish a local Estes Arts District. (Courtesy and copyright of James Frank.)

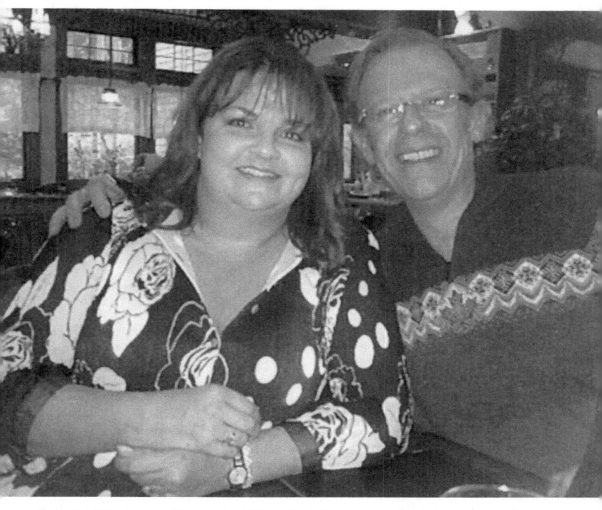

Rob and Julie Pieper, Poppy's and Mama Rose's
"Let's meet at Poppy's" is an often-heard comment among Estes Park locals looking for a microbrew and a tasty pizza. Across the way is Mama Rose's for a glass of wine and elegant Italian cuisine without the elegant prices. Residents since the 1980s and business people since 1994, Rob and Julie Pieper run two popular restaurants on Elkhorn Avenue. Huge fans of the Disney culture, the Piepers often vacation at Disney World and return with new ideas on how to improve their restaurants. Rob and Julie are never too busy to host fundraising dinners for Partners Mentoring Youth, Estes Park Learning Place, and Restorative Justice, to name a few. To coordinate efforts and share resources among local restaurants, Rob and Julie formed the Estes Valley Restaurant Partners, which then began Estes Park Restaurant Week. (Courtesy of Kris and Gary Hazelton.)

Architect Roger Thorp and Thorp Associates

Roger Thorp's "gentle architecture" welcomes all who travel to Estes Park. As visitors descend down Highway 36, many stop for a photograph next to the huge stone slabs with the sand-blasted announcement that they have arrived in Estes Park. This pro bono, Rotary-sponsored project received an Honor Award for Design Excellence from the American Institute of Architects. Farther down the highway is the Dannels Fire Station, positioned below a rise in the Bureau of Land Management property next to Lake Estes. Downtown is the Estes Valley Library, the town council chambers, and Barlow Plaza, as well as numerous commercial structures remodeled to improve the character of the business district. Farther west on Elkhorn is the summer entertainment venue Performance Park Pavilion, nestled on a natural oxbow of Fall River. Near the north entrance to Rocky Mountain National Park is the award-winning visitor center. Among the firm's other major municipal projects are the Estes Park Conference Center and the new grandstand for Stanley Park. Thorp, who founded his firm in Estes Park in March 1976, graduated from the Kansas State University School of Architecture in 1970 and has completed graduate work at Harvard School of Design. He is licensed in 16 states and two Canadian provinces. But it is Estes Park that is Thorp's home, and his values show in the firm's environmentally sensitive designs. When the library board began the design process for a new library in 1990, Thorp utilized redwood siding, sloped roofs, and moss rock to recall the nature of early 20th-century national park administration buildings. A longtime Rotarian, Thorp provides pro bono services, such as the design of the 11,000-square-foot, two-story Salud Family Health Center and the award-winning outdoor children's reading area west of the library. Thorp Associates is currently designing the Rocky Mountain Performing Arts Center. (Courtesy of Roger Thorp.)

CHAPTER SIX

Making a Difference

Dedicated volunteers and public servants make up the backbone of a community. Recognizing a need, the Estes Park Woman's Club improved roads and trails and financed the construction of a permanent library building in 1922. World War II veterans Bob Brunson and Vern Mertz helped form the Estes Park Honor Flight Committee to help raise money to send veterans to Washington, DC, to tour the war memorials. Not wanting people to eat alone on Thanksgiving, Larraine Darling and Steve Misch lead a group of volunteers who serve a complete turkey dinner with all the trimmings. Those who grew up in Estes Park remember doctors Jacob Mall and Sam and Julie Luce making house calls or helping with rescues on Longs Peak. As medical director of Timberline Medical, soft-spoken Paul Fonken was named the 2013 Family Physician of the Year by the Colorado Academy of Family Physicians. The Estes Park High School has had many excellent teachers, among them beloved football coach Perry Black and eighth grade teacher Jeff Arnold, who brings history alive for students through Washington, DC, tours and the Ellis Island immigration experience. Under the leadership of Chuck and Julie Varilek, the high school marching band won the state championship in 1998 and 2004. As head of school at Eagle Rock, Robert Burkhardt helped form an innovative learning experience that intervened in the lives of young people by promoting community, integrity, and citizenship. Estes Park volunteers include Ross Moor, who became a driving force in building a new senior center, and Katie Speer, who raised more than $1 million with her grant writing. Outdoor enthusiast Jean Weaver inspired a blossoming recycling movement, while the Estes Park Pet Association became a fixture in town once animal lover Carolyn Fairbanks was elected president. At the library, Lennie Bemiss preserved local history while children's librarian Kerry Aiken inspired children to read through the innovative use of puppets and props. Then there are people who do the right thing, like engineer Paul Van Horn, who worked on the 13-mile tunnel beneath the Continental Divide as part of the Colorado–Big Thompson Water Project, and Ned Linegar, who was program director at the YMCA of the Rockies for years before switching gears to become executive director of the Estes Park Chamber of Commerce. For 27 years, managing editor Tim Asbury was the heart and soul of the *Estes Park Trail-Gazette*, leading his newspaper to dozens of awards in photography, reporting, and editorial writing.

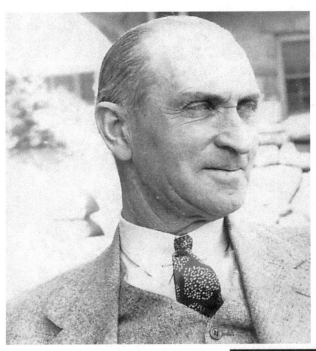

Charles Bryon Hall (1878–1944), F.O. Stanley's Right-Hand Man

When F.O. Stanley wanted something accomplished, he turned to longtime friend Charles Bryon Hall. With Stanley's financing, Hall and his father, J.B., constructed the first automobile road into Estes Park, allowing Stanley Steamers to bring guests to Estes Park. Hall built the Estes Park water system in 1908 and completed the Fall River hydroplant in 1909 to provide power to the Stanley Hotel. For years, he was manager of the Light and Power Company and was also one of the organizers of the chamber of commerce, serving as president in 1937–1938. He served on the town board from 1929 to 1940. (Courtesy of Estes Park Museum.)

Harriet Burgess (1925–2012) and Estes Park History

If one wanted to know about local Estes Park history, it was best to check with Harriet Burgess. She met her husband, Bill, in 1949 and was bookkeeper at the Old Plantation Restaurant. Harriet immersed herself in local history, becoming MacGregor Ranch volunteer coordinator for two decades. Named 1986 Woman of the Year, she was involved with the Community Church, the Estes Park Planning Commission and Library Board, United Way, Quota Club, Presbyterian Women, and League of Women's Voters. She was president and 50-year member of the Woman's Club. Harriet wrote *Then the Women Took Over: The 100 Year History of the Woman's Club*. (Courtesy of Debbie Burgess Richardson.)

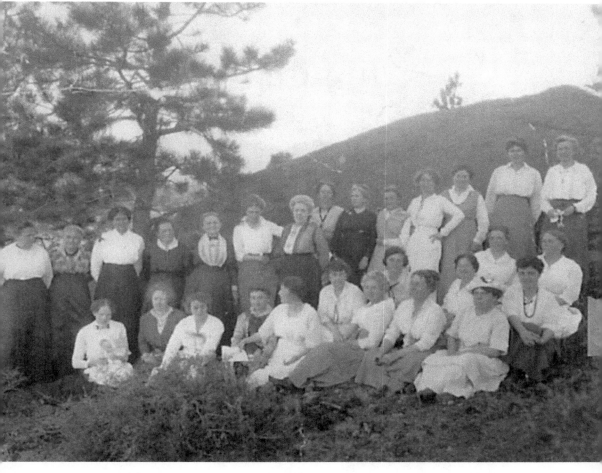

The Estes Park Woman's Club

In the summer of 1912, the women of Estes Park held bazaars, dances, and minstrel shows to raise money for road and trail improvements. But when Eleanor Hondius brought $300 to a fall meeting of the Estes Park Business Association and suggested a number of improvements, she was told an "auxiliary" could not dictate the use of the money. Hondius put the money back in her purse and left the meeting. That fall, under the leadership of Imogene MacPherson and Mary Belle King Sherman, the Estes Park Woman's Club was formed. They loaned $100 to a village committee to purchase a town sprinkler cart to settle the dust on Elkhorn Avenue and, in 1916, founded the Estes Park Library as a room in the school. One of the club's biggest accomplishments was financing the construction of a permanent library building in 1922 at a cost of $5,000. The Town of Estes Park donated the land in Bond Park, and the women paid for the building with a certificate of deposit, a Liberty Bond, donations, a $700 loan from the bank, and numerous moneymaking projects. The Woman's Club continues to be a vibrant part of the community, establishing a scholarship and education fund and supporting the volunteer fire department, Boy Scouts, and a community Christmas tree. (Courtesy of Estes Park Museum.)

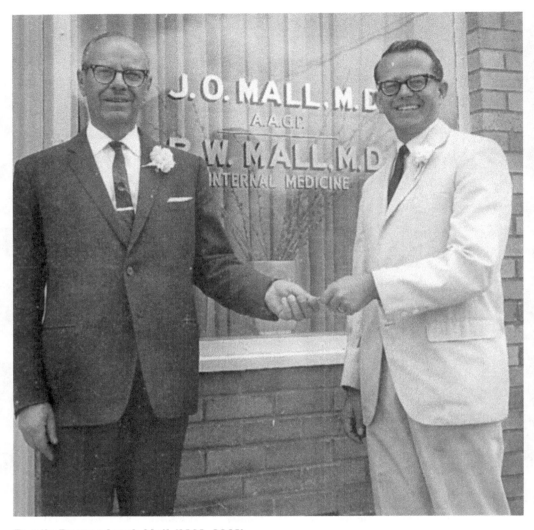

Family Doctor Jacob Mall (1902–2003)
Those who grew up in Estes Park during the middle of the last century remember family doctor Jacob Mall. Mall graduated from the University of Nebraska's College of Medicine in 1931 and opened for business in Estes Park in the fall of 1932. Office calls were $2, and home visits were $4, including hundreds of babies delivered at home. One of his first calls was for a heart attack at Lost Lake, 10 miles one way by horse. In 1938–1939, Mall took a postgraduate course in surgery in Chicago and, after serving in the Pacific in World War II, returned and opened an overnight acute care facility called the Estes Park Hospital, which was patterned after evacuation hospitals he had commanded during the war. His son Ronald Wayne Mall followed him into medicine, practicing with his father from 1967 to 1969. A familiar landmark in Estes Park is the Mall House, a 14-room home Mall built in 1938, which now overlooks Lake Estes. It is located on five acres and featured a barn, corral, and three-hole golf course. Mall's wife, Marion, said that she would title her memoirs *I Lived by a Dam Site*. Mall retired in July 1971, after practicing medicine for 39 years. (Courtesy of Estes Park Museum.)

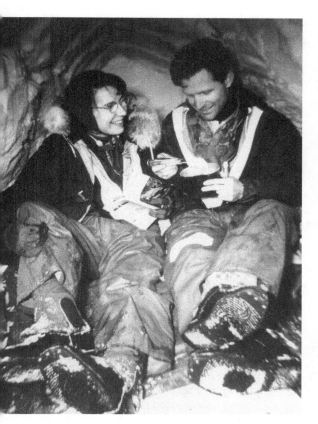

Doctors Sam and Julie Luce and Mountain Medicine

Doctors Sam and Julie Luce rode horses, raised cattle, and cross-country skied across the Continental Divide. After Sam and Julie met at Baylor Medical School, they established their practice in Estes Park in 1958. Julie was a pediatrician and Sam a general practitioner who frequently accompanied park rangers on search-and-rescue operations in Rocky Mountain National Park. One winter night, he carried a 50-pound pack up the Longs Peak trail in a ground blizzard to aid a climber who had fallen from the Diamond. In their spare time, Sam and Julie went on cross-country ski trips in the backcountry with their friends Bob and Teddie Haines. They lived on 140 acres near Marys Lake and raised three children, along with long-haired Scottish Highlander cattle. In 1972, Sam and Julie bought a ranch in Arizona. (Left, courtesy of Robert J. and Theodora A. Haines; right, courtesy of Estes Park Museum.)

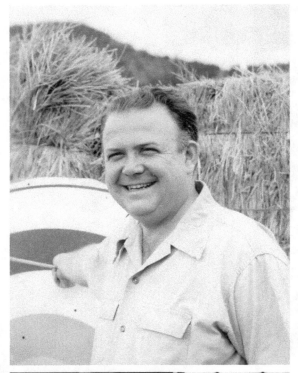

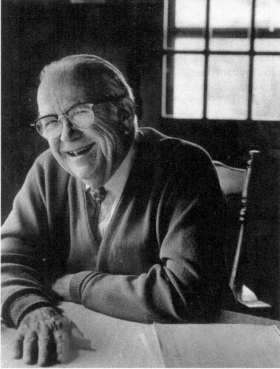

Renaissance Man D. Ned Linegar (1914–2010)

When his eyes twinkled, one knew D. Ned Linegar was about to recite one of his many poems. While working at a Dallas YMCA from 1949 to 1957, Linegar and his wife, Margaret, spent their summers as program directors at the YMCA of the Rockies. With the motto "never cancel a program event," the Linegars offered music, art, hiking, worship services, horseback riding, youth programs, family cookouts, songs, skits, and games around the campfire. When the YMCA opened year-round in 1958, Linegar moved his family to Estes Park. In 1961, he switched gears, serving as Estes Park Chamber of Commerce executive director until 1968. He also helped establish the Estes Park Church of the Air and the Estes Park Area Museum, and was a founding member of the Fine Arts Guild of the Rockies, where he directed and performed in plays. (Top, courtesy of YMCA of the Rockies, Lula W. Dorsey Museum; bottom, courtesy of Estes Park Museum.)

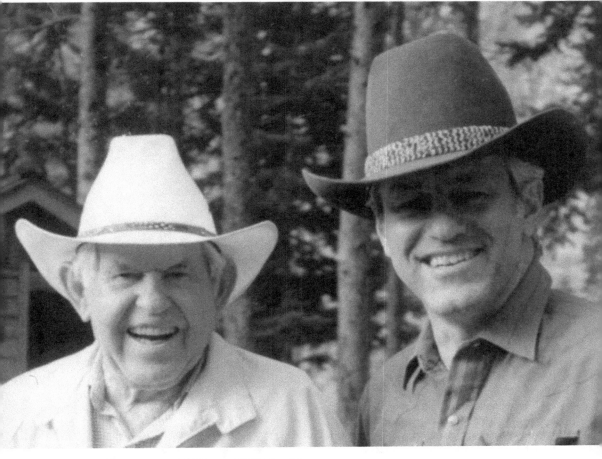

Engineers Paul (1912–2000) and Bill Van Horn
Imagine drilling a 13.1-mile tunnel 4,000 feet beneath the Continental Divide, the centerpiece of the Colorado–Big Thompson Water Project. One group of workers tunneled from the Grand Lake side, and the other workers dug from the Estes Park side. Faced with this surveying task was Paul Van Horn, who graduated from Colorado A&M (now Colorado State University) in 1935 with a civil engineering degree. After every blast, crews measured and marked the inside of the Alva B. Adams tunnel horizontally and vertically. Van Horn used a theodolite (angle surveying instrument) to accomplish his triangulation work. When the tunnel "holed through" in June 1944, four years after drilling began, the meeting point was only off alignment by 7/16 of an inch. In June 1947, the first water flowed eastward from Grand Lake, through the Alva B. Adams Tunnel to Lake Estes. Van Horn received a Merit Choice Award from the secretary of the interior for his engineering work. After he retired from the Bureau of Reclamation in 1948, he began his own engineering firm and opened the Hobby Horse Motel. His son Bill Van Horn took over Van Horn Engineering in 1978 after working as public works director, engineer, and planner for Estes Park. Bill retired in 2003, but Van Horn Engineering continues to thrive 67 years after Paul founded it. The Colorado–Big Thompson Water Project delivers 213,000 acre-feet of water annually to 30 towns and cities on the Front Range. (Courtesy of Bill Van Horn.)

Jean Weaver, the "Queen of Recycling"

Most Wednesdays at noon, Jean Weaver can be found at the corner of Bond Park with other Patriots for Peace volunteers holding a placard that says "Honk 4 Peace." Weaver was a ski instructor at Hidden Valley, where she worked for 14 years, and a hiker who has climbed all the 13ers in Rocky Mountain National Park. But most residents know her as a passionate conservationist who has been recycling in Estes Park for nearly 40 years. It began in 1975 when Claudia Irwin asked Weaver to help with a newspaper recycling drive to support her high school choral group. Weaver took it one step further, becoming the driving force behind a blossoming recycling movement that has developed into the second longest continuous recycling program in Colorado, next to Boulder's Eco-Cycle. In 1978, before recycling became popular, Weaver and Irwin salvaged 46,400 pounds of glass and 168 barrels of flattened tin and steel. Now, recycling is a normal part of most people's everyday routine in Estes Park, thanks to Weaver's untiring efforts. In 2015, Mayor Bill Pinkham honored Weaver the "Estes Valley Recycling Queen" for her contributions, including her work with the League of Women Voters and the Estes Valley Bear Education Task Force. (Courtesy of Steve Mitchell.)

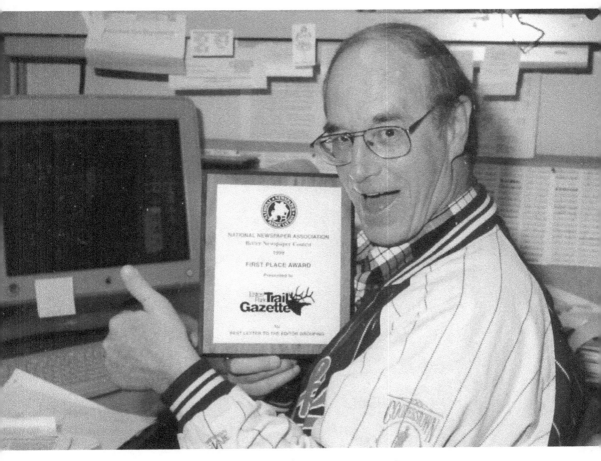

Editor Tim Asbury (1949–2004) and the *Estes Park Trail-Gazette*
On his first assignment for the *Estes Park Trail-Gazette* in September 1972, 23-year-old Tim Asbury wore a suit and tie as he trudged around a helicopter crash site near Glen Haven. Staff members swear that was the last time Asbury wore a suit to work. On long press days, Asbury survived on Coke, Chex Mix out of the box, and pastries from the Donut Haus down the street. After graduating from the University of Colorado with a degree in journalism and mass communication in 1972, Asbury married his high school sweetheart, Nancy, and dropped off his job application at the *Trail-Gazette* while they were on their honeymoon. During his 28-year tenure, Asbury tackled Estes Park's sacred cows with his incisive editorials and, as managing editor, led his newspaper to dozens of awards in photography, reporting, editorial writing, design, and distinctive headlines. The *Trail-Gazette* was recognized as best newspaper of its size in the United States by the National Newspaper Association and three times honored as the best newspaper in the state by the Colorado Press Association. A consummate professional, Asbury was recognized as the top photojournalist in the state by the Colorado Press Association for his coverage of the 1976 Big Thompson Flood. Asbury worked hard and played hard, competing in the battle of the media stars, taking part in the elk chip toss at Aspenfest, and joining fellow staffers Dave Thomas and Dan Campbell in a cattle dressing contest at the Colorado High School rodeo finals. Former *Trail-Gazette* reporter Jackie Hutchins said, "Tim Asbury was the heart and soul of the *Trail-Gazette* through four different ownerships from 1973 to 1999. He's legendary to me." (Courtesy of Jill Black.)

Banker George Hix (1928–2010)

Service above self was central to George Hix's life. A former president and secretary of the Rotary Club of Estes Park, Hix maintained perfect attendance for 51 years. Born in Estes Park in 1928, he graduated from Estes Park High School in 1947 and earned a bachelor of arts in business administration from the University of Colorado. After service in the Air Force and work as a bank examiner for the Federal Reserve Bank in Kansas City, Hix returned to Estes Park in 1956 to become vice president of the Estes Park Bank. He married Glonda Hix in 1964. During his 42 years at the bank, he applied his Rotary Club ideals to public life, often sealing deals with a handshake. With a twinkle in his eye, Hix loved to poke fun at himself and dress up as Scrooge at Christmas. He served on the town board for 16 years, also serving as mayor pro-tem. He served on the Estes Valley Recreation and Park District Board for 24 years, served on the Town Planning Commission (1979–1990), the Estes Valley Planning Commission (2002–2006), as a director of the Estes Valley Land Trust (1987–1993), and as a member of the Estes Park Urban Renewal Authority (1994–1996). Hix was also involved with Rooftop Rodeo, the local Boy Scouts, and the Forward Estes Foundation. The George J. Hix Riverside Plaza was named in his honor in the summer of 2015. (Courtesy of Kim Stevens.)

Local History Librarian Lennie Bemiss (1926–1995)
Once Lennie and Bob Bemiss settled in their new Estes Park home in 1972, Lennie walked into the Estes Park Library and asked director Ruth Deffenbaugh if she needed any volunteers. From that day forward, Lennie and Ruth developed one of the finest small-town libraries in the state. They attended Colorado Library Association workshops to learn what "the big kids did." One of their success stories was developing the library's extensive Colorado Collection, which was previously uncatalogued and hidden on two tiny shelves. Lennie also developed a vigorous volunteer program, recruiting workers to shelve and check out books as well as index the *Estes Park Trail-Gazette*. In addition, she was chairman of the oral history project and a board member of the Estes Park Museum. Her husband, Bob, helped with handyman projects around the library and served as president of the Library Foundation Board. (Courtesy of Estes Valley Library.)

Coach Perry Black (1939–2015)
Through the good seasons and the tough seasons, education came first for Coach Perry Black. He told his football players that few of them would play college ball, so they had better buckle down and study. Before coming to Estes Park in 1975, Black earned his master of science at Central Missouri State University in 1966 and coached Missouri high school football for nine years, winning the State Class "A" championship in 1972. Black spent 30 years in the Estes Park School District, coaching varsity football for 16 years and earning the Longs Peak League Coach of the Year Award for directing the Bobcats to a league championship with an 8-2 record in 1984. He also coached track and basketball, taught physical education, and took on stints as athletic director and assistant principal. A teacher and student favorite, Black won School Employee of the Month in 2004. The Estes Park Schools showed their appreciation for Black's long service in education by naming the Perry Black Fitness Center in his honor. Black and his wife, Judy, were married 52 years and had three children and eight grandchildren. (Courtesy of Estes Park Museum.)

Senior Center Volunteer Ross Moor (1906–2011)
When Ross and Lois Moor retired to Estes Park in 1975, they became active in the community, especially the senior center. Ross was the driving force in building a new senior center in 1979. One tribute to Ross said, "This friendly, cheerful fellow has many talents, which he donates to the Senior Center— fence put 'er upper, tree and bush mover, flower planter, builder, painter, gardener, money picker upper, bookkeeper, bill payer, board member and treasurer, and Nebraska-born, Wyoming girl snatcher." Born in Nebraska, Ross worked as an engineer in Wyoming, Virginia, West Virginia, Kansas, Nebraska, Ohio, Mississippi, Texas, and Georgia. (Courtesy of Estes Park Senior Center.)

Animal Champion Carolyn Fairbanks
For 25 years, Carolyn Fairbanks has brought dogs, cats, and even the occasional potbellied pig to the residents at the Estes Park Nursing Home, one of the first in the area to provide pet therapy. "People's faces just light up when she arrives," said Lori Mitchell, former nursing home activities director. The nonprofit Estes Park Pet Association became prominent in town once Fairbanks was elected president in 1990. The pet association places more than 100 pets a year, with a 98 percent adoption rate. (Courtesy of Steve Mitchell.)

Inspiring Kids to Read with Kerry Aiken
When Kerry Aiken appeared for her job interview for children's librarian at the Estes Park Public Library, she brought along her puppets to show how entertaining children can motivate them to read. When Aiken walked out of the interview room, her alligator puppet stared over her shoulder and demanded, "Hire this woman!" For 25 years, Aiken inspired children to read through preschool and after school story times, as well as through a themed reading program to keep children reading all summer long. Drawing on 70 thematic programs on file, Aiken and her assistant Melanie Kozlowski explored reading with picture books, puppets, props, and music. This laid the groundwork for language development in a young child's rapidly growing brain, while helping to instill an enjoyment of books and reading. Aiken's reading programs have been so successful that the children she first motivated to read are bringing their children to story time. And it all began with a puppet. Aiken retired in the fall of 2015. Here, Kerry shows a puppet to Matt Van Westen and his son Jake. (Courtesy of Steve Mitchell.)

Making Music with Chuck and Julie Varilek

Chuck likes jazz and Julie likes country, but together the Varileks have made beautiful music for Estes Park schools for a quarter of a century. Chuck and Julie taught 11 years in South Dakota before coming to Estes Park in 1989. While Chuck revived the band program, Julie took Gail Fray's place in the elementary school five years later and taught children the fundamentals. Then, Chuck introduced instruments to the children in fifth grade. Both credited Fray for establishing a strong music foundation for the kids. The award-winning Estes Park High School marching band appeared in the state finals 18 straight years and won the state championship in 1998 and 2004, often competing against schools twice their size. Chuck and Julie retired in May 2014, leaving more time to devote to the Village Band, the Jazz Big Band, and their group Just Us. (Left, courtesy of Chuck and Julie Varilek; below, courtesy of Steve Mitchell.)

Bringing History Alive with Jeff Arnold

When Jeff Arnold is not bringing history alive for his eighth grade students, the lifelong learner spends summers touring Civil War battlefields and attending classes through a four-day Teacher Institute. In his spare time, he learns economics and reads history. A 1980 graduate of Estes Park High School, Arnold earned his bachelor of arts degree from the University of Northern Colorado and began substitute teaching and coaching at Estes Park schools in 1984. Once he began teaching full-time in 1989, he split his time between middle and high school but gravitated back to eighth grade. "I'm just the world's oldest eighth grader," Arnold laughed. "You have to be an actor, a performer. You have to be lighthearted." Every year, Arnold immerses his students in the immigrant experience of 1900 with his Ellis Island simulation. For a day, eighth graders experience the apprehension and fear immigrants felt when they entered the country. For 23 years during spring break, Arnold has taken eighth-grade students to Washington, DC, to tour the Capitol, the Supreme Court, and the Smithsonian—with a side trip to Gettysburg. Arnold has noticed how the experience changes his students. "These kids became the leaders in the class for the rest of the year. They had a confidence and were so much more participatory." For most of his teaching career, Arnold coached middle school football and track, as well as freshman boys' and girls' high school basketball. In 1995–1996, Arnold took a leave of absence and earned a master's degree at the University of Michigan in social studies education. He recently renewed his National Board Certification, the teaching profession's highest credential. (Courtesy of Steve Mitchell.)

Head of School Robert Burkhardt and Eagle Rock

Before leading the early-morning run to the gate at Eagle Rock, head of school Robert Burkhardt instructed his students to "reach up, stretch yourself"—not only to wake up stiff muscles but to change the way they lived their lives. "Leave this place better than the way you found it," Burkhardt stressed. "Find a need and fill it." American Honda Corporation hired Burkhardt in 1991 to help realize a vision of forming a school that would intervene in the lives of young people by promoting community, integrity, and citizenship. Together with Honda's Tom Dean and Makoto Itabashi, Burkhardt toured 93 sites in Colorado before settling on the property off Dry Gulch Road. Burkhardt made his pitch to Estes Park—clean industry, year-round local jobs, and no cost to the community—but still met resistance. When asked how Estes Park would accept inner city kids who had struggled in conventional school settings, Burkhardt stressed public service. "When you see our kids, they will have a shovel or rake in their hands." The first group of students arrived in September 1993 from throughout the United States to find Burkhardt, his wife, Lizzie, and their children living on campus and engaged in students' lives. "The biggest perk of the job is living in a multiracial mountain setting," Burkhardt said. Burkhardt imparted a lasting legacy when he and his family left the school in September 2012. An internal study found that 88 percent of all entering students ultimately earned a diploma from Eagle Rock, a diploma from another high school, or a GED. More than 60 percent have attended college. (Courtesy of Robert Burkhardt.)

Leader in Global Medicine Dr. Paul Fonken
Soft-spoken and compassionate Paul Fonken, MD, puts his patients at ease the moment he walks into the examining room. As medical director at Estes Park Timberline Medical, Fonken incorporated electronic health records, designing most of the clinical protocols and templates. In 1997, he took a leave of absence from his family practice to spend nine years introducing the family medicine specialty in Kyrgyzstan. The Colorado Academy of Family Physicians named him the 2013 Family Physician of the Year for his leadership in global medicine and medical reform. Recently, Fonken was named chief of staff at the Estes Park Medical Center. (Courtesy of Estes Park Medical Center.)

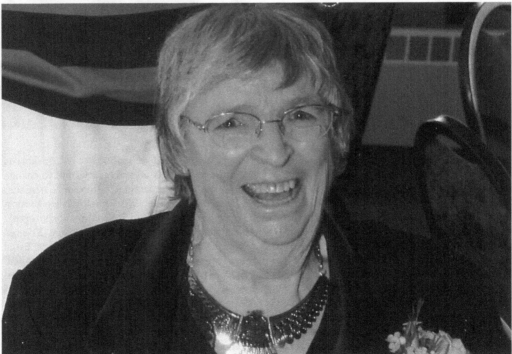

Philanthropist Catherine "Katie" Speer (1930–2014)
After Catherine "Katie" and Howard Speer moved to Estes Park in 1994, Katie served on the boards of Crossroads Ministry and the Estes Park Library Foundation while helping to develop the Estes Park Nonprofit Resource Center. Katie's grant writing raised more than $1 million, so the Town of Estes Park honored her as the 2006 Volunteer of the Year. In 2009, Katie wrote a grant for the Estes Valley Library, which launched Common Cents Counts, a five-year financial literacy education program. The library named Katie 2011 Volunteer of the Year. (Courtesy of Ken Springsteen.)

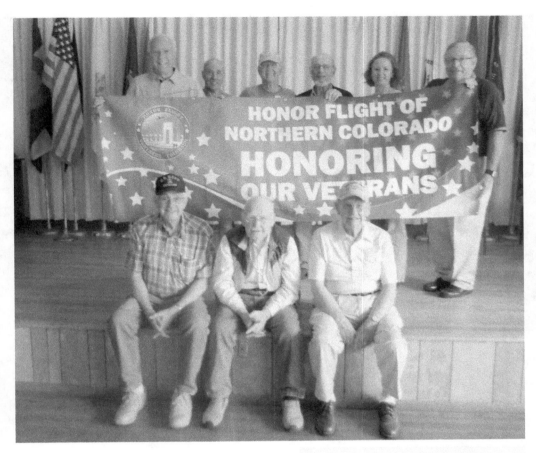

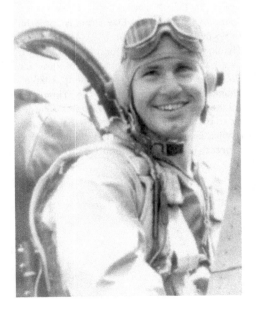

Bob Brunson and Vern Mertz with Honor Flight

After the attack on Pearl Harbor, Bob Brunson trained as a naval aviator and saw combat as a night fighter pilot flying Corsairs aboard the USS *Enterprise.* During the 36-day Iwo Jima campaign, Vern Mertz made 45 amphibious landings while stationed aboard the landing ship *LSM 207.* In 2010, Honor Flight of Northern Colorado sent Bob Brunson, Vern Mertz, and 118 other World War II veterans to Washington, DC, to tour the war memorials. Veterans are not allowed to pay a single cent of the $1,000 cost. To say thank you, Brunson and Mertz helped form the Estes Park Honor Flight Committee to assist in raising money for future Honor Flights. For the past five years, Estes Park Honor Flight has raised more than $87,000 to send 67 Estes Park area veterans on Honor Flights. Above, Vern Mertz (left) and Bob Brunson (center) are seated in the front row. (Above, courtesy of Steve Mitchell; right, courtesy of Bob Brunson.)

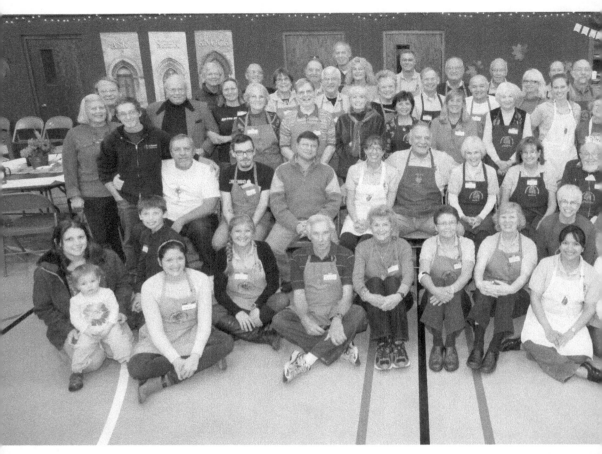

Larraine Darling and Steve Misch with the Thanksgiving Day Feast (ABOVE AND OPPOSITE PAGE)
Spending Thanksgiving Day alone is something Larraine Darling and Steve Misch do not want anyone to do in Estes Park. So, in 2001—with the support of Estes Valley Sunrise Rotary—they put on a free Thanksgiving Day dinner for a few people at Darling's Notchtop Café. Today, the feast has mushroomed to a packed gym at the Mountain View Bible Fellowship Church, which serves nearly 700 people. Everyone enjoys live entertainment, a bake sale table filled with homemade goodies, and a complete Thanksgiving dinner with all the trimmings. For those who cannot make it to the church to eat, volunteers bring the meal to homes. The feast is free, thanks to generous community donations and more than 100 volunteers. More than a buffet line, this event is a community gathered together to give thanks. Everyone has an opportunity to write a message of gratitude on the "wall of thanks." (Above, courtesy of Tony Bielat; opposite, courtesy of Steve Mitchell.)

Cynthia and David Krumme (1948–2013) and the Bella Fortuna Center
"Are you off to make a difference?" is a question David and Cynthia Krumme often asked themselves at the beginning of the day. After marrying young and earning advanced degrees at the University of California at Berkeley, David taught at Tufts University while Cynthia taught high school. But the Rocky Mountains inspired their daughter Catherine Krumme in her battle with leukemia, so the Krummes moved to Estes Park in 2004 and bought Airbits, a high-speed Internet company. While David, Cynthia, and son Matthew Krumme grew Airbits into a thriving Internet provider, Catherine taught at the Learning Place, which offers one-on-one tutoring and small group activities to help students achieve their goals. Seeking to "make a difference" in their community, David and Cynthia founded the Bella Fortuna Center, which provides rental space to education-oriented nonprofits. The couple started the project with their own money, but when David died suddenly in February 2013, $150,000 came in the form of donations honoring David's life. Cynthia and her son Matthew worked with architects and contractors to complete the project, and on October 1, 2013, Bella Fortuna opened. It now houses the Estes Park Learning Center, Partners Mentoring Youth, Loving Spirit Inc., and the Estes Valley Investment in Childhood Success. In November 2013, David received the Lifetime Philanthropic Achievement Award for his work with Bella Fortuna. Cynthia continues her work with nonprofits on the Estes Park Nonprofit Resource Center Board, while daughter Catherine touches the plaque dedicated to her father every day she works at the Learning Place. (Courtesy of Cynthia Krumme.)

CHAPTER SEVEN

Larger than Life

Estes Park is not Estes Park without the larger-than-life people and events that make it exceptional. "Miner Bill" Currence butted heads with the National Park Service as he prospected on the slopes of Mount Chapin in the early 1900s, while *Denver Post* reporter Al Birch hired a girl to disappear into Rocky Mountain National Park for a week as a "modern-day Eve." Charles Eagle Plume performed dances for summer tourists and championed Indian rights. Retired to a cabin near Allenspark, few knew that Ray Fitch had run in the 1924 Olympics in Paris, coming in second to Eric Liddell, immortalized in the movie *Chariots of Fire*. Joseph "Junior" Duncan won the second annual US National Amateur Ski championships before he won the Silver Star and two Bronze Stars in World War II. Madame Kathryn told the fortunes of the stars before escaping the heat in Estes Park, where she spent the next 52 summers fortune-telling. Every summer, "Casey" Martin invited visiting children to ride his Silver Streak train around the quarter-mile track through Lollipop Land, past Humpty Dumpty and Red Riding Hood. Seeking to extend the 100-day summer season, Jim Durward suggested holding a Scottish-Celtic festival, which has grown into one of the largest events of its kind in the nation. Tim Mayhew worked at the fairgrounds, but his true home was the mountains, where he would disappear to hunt elk, bear, and moose. If you had not been called "Virgil" or "Virgette," then you did not know Tim. Ed Kelsch was known to get a little "crazy," running down Elkhorn in a gorilla suit, mooning tourists, and dressing up in red, white, and blue on the Fourth of July. Eric Adams has helped preserve the ranching life in the Estes Valley—first at MacGregor Ranch and today at Crocker Ranch. Wendy Koenig Schuett grew up in Estes Park and went on to break running records at Colorado State University and compete in the 1972 and 1976 Olympics. Named "Rooftop Rodeo" because of the town's 7,522-foot altitude, the award-winning, small-town rodeo is billed as the highest altitude rodeo competition in America. These exceptional people and events make Estes Park a special place.

Ralph Gwynn and the Park Theatre
The bright red, green, and white neon lights on the Park Theatre's 80-foot tower illuminate the dark Estes Park sky. Ralph Gwynn bought the theater in 1922 and built the distinctive white tower in 1926 after his bride-to-be left him standing at the altar. Legend says he left the tower intentionally empty as a symbol of the hollow heart of the woman who refused his love. Gwynn died in the theater in 1963, and some still feel his ghost. The Park Theatre is the oldest, still-operating theater west of the Mississippi. (Courtesy of Steve Mitchell.)

"Miner Bill" Currence and his Claims
In the early 1900s, "Miner Bill" Currence built cabins and prospect holes on the slopes of Mount Chapin, two miles above Chasm Falls near Miner Bill's Spire. When Rocky Mountain National Park was established in 1915, Miner Bill butted heads with the superintendent, stringing barbed wire across Fall River Road, claiming it interfered with his prospecting. When he was forced off his claim in 1930, F.O. Stanley gave him a place to live and odd jobs around the hotel. Miner Bill told the tale of the glowing "Blue Mist" that left claw marks in the snow and struck animals dead. (Courtesy of YMCA of the Rockies, Lula W. Dorsey Museum.)

Horatio "Ray" Fitch (1900–1985) and Chariots of Fire

The Academy Award–winning movie *Chariots of Fire* is about Eric Liddell's victory in the 400 meters race at the 1924 Olympic Games in Paris. However, the favored American who finished second was Horatio "Ray" Fitch, who grew up in Chicago and competed on the University of Illinois track team. After finishing second to Liddell in the Olympics, Fitch worked as an engineer before retiring to Allenspark in 1969 with his wife, Dorothy. When the movie came out, Fitch's daughter called from Illinois, asking, "Dad, do you know you're in the movies?" Ray was stunned, retorting, "The heck you say!" Fitch is pictured second from the left, finishing second to Liddell. (Courtesy of Ted Schmidt.)

Albert "Al" Birch and the Modern-day "Eve" in Rocky

Denver Post reporter Albert "Al" Birch convinced photography clerk Hazel Eighmy to wear a leopard skin and pose as a present-day "Eve" to promote Rocky Mountain National Park in 1917. Enos Mills and park superintendent L. Claude Way shook hands with the daring girl before she embarked for a week in the wilderness. Birch had built a house on the knoll overlooking Estes Park 10 years earlier. On a bitter December day that same year, Birch emerged gasping from his burning house after wooden floor joists under the roaring fireplace ignited. The Birch Ruins are visible on the knoll to this day. (Courtesy of Jack Melton.)

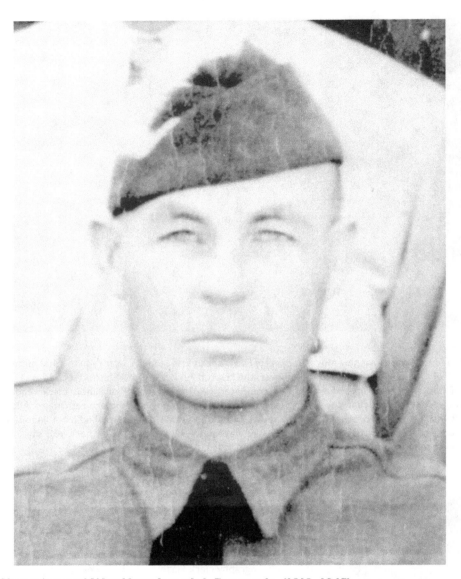

Ski Champion and War Hero Joseph J. Duncan Jr. (1912–1945)
"Junior" was the son of larger-than-life Joseph "Judge" Duncan Sr. Joseph Duncan Jr. soon emerged from his father's shadow, voted Best All-Around Boy of Estes Park High School and graduating as 1931 class valedictorian. But the mountains were Duncan's true love. He shadowed ranger Jack Moomaw on backcountry ski trips, becoming an excellent skier who won the second annual US National Amateur Ski championships in 1934 on "Suicide Trail," the course Moomaw designed at Hidden Valley in Rocky Mountain National Park. Duncan's skiing took him around the world until he landed at Sun Valley, Idaho, where he was a ski instructor and lodge manager. At the start of World War II, Duncan volunteered for the newly formed 87th Mountain Infantry Battalion at Fort Lewis, Washington. He rose to captain and was sent to Naples, Italy, in the closing months of World War II. An outstanding combat leader, Duncan earned a Silver Star and two Bronze Stars before being killed in combat on April 17, 1945, near the village of Cas Costa. On October 8, 2002, members of Estes Park American Legion Post No. 119 voted to dedicate the post to Joseph J. Duncan Jr. (Courtesy of American Legion Post No. 119.)

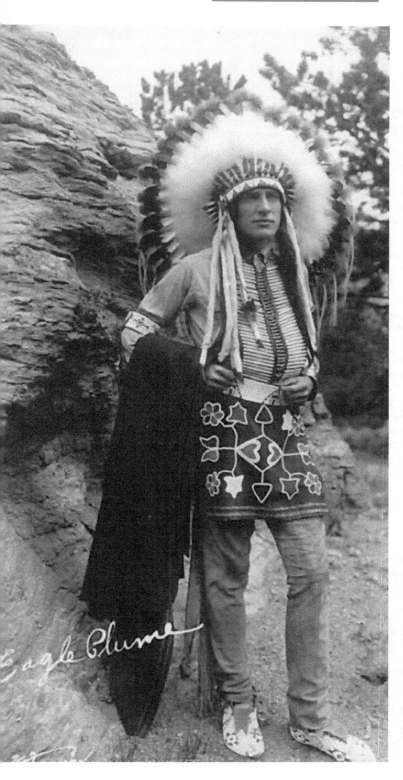

Eagle Plume

Indian Activist and Entertainer Charles Eagle Plume

Born Charles Frederic Burkhardt, the man who would come to be called Charles Eagle Plume arrived in Estes Park in 1917. For 12 years, he and Ray Silvertongue performed Indian dances for visitors at Estes Park. In 1927, O.S. and Katherine Perkins offered Burkhardt a summer job at the Perkins Trading Post near Allenspark, where he entertained guests. A woman captivated by his performances paid for his room and board at the University of Colorado. After Charles graduated in 1932, he worked at the store full-time in the summer and toured the country in the winter, championing Indian rights and lecturing on Indian art, song, dance, sign language, and culture. His presentations were interspersed with humor to capture the attention of young children. After serving as an Army scout in the Solomon Islands during World War II, Eagle Plume returned to help Katherine Perkins run the store until she died in 1965. Inheriting the store from a grateful Katherine, he changed its name to Charles Eagle Plume Trading Post, which was where he entertained countless guests and customers and gave the lucky child an arrowhead. (Courtesy of Estes Park Museum.)

Rooftop Rodeo

Named Rooftop Rodeo because of Estes Park's 7,522-foot altitude, the small-town rodeo is billed as the highest altitude for any rodeo competition in America. In the early 1900s, townspeople gathered for Fourth of July celebrations and watched bronco busting, roping, branding, and steer riding while they ate their holiday pie. Now in its 89th year and under the direction of chairman Mark Purdy, the Rooftop Rodeo is held at the Stanley Park Fairgrounds and hosts some of America's best cowboys and cowgirls competing in bareback bronc riding, team roping, saddle bronc riding, tie-down roping, steer wrestling, barrel racing, and bull riding. The Rooftop Rodeo has been voted the Professional Rodeo Cowboys Association's Best Small Rodeo of the Year five times and nominated for Best Medium-Sized Rodeo of the Year in 2012 and 2013. (Both, courtesy of Estes Park Museum.)

Aerial Tramway Pioneer Robert Heron (1914–1999)
The Estes Park Aerial Tramway ascends 1,100 vertical feet up the side of Prospect Mountain in less than five minutes. Designed in 1955 by ski lift and aerial tramway pioneer Robert Heron, the Estes Park Aerial Tramway has taken more than three million visitors up Prospect Mountain. Heron first designed tramways for the 10th Mountain Division at Camp Hale, a system that followed them into action during World War II. After the war, the Heron Engineering Company installed the highest rated chairlift in Aspen and constructed the first fixed grip continuous circulating double chair in the world for Berthoud Pass in 1946. His companies designed 78 lifts and tramways around the world, including 30 in Colorado. (Top, courtesy of Colorado Ski & Snowboard Hall of Fame Archives; bottom, courtesy of Steve Mitchell.)

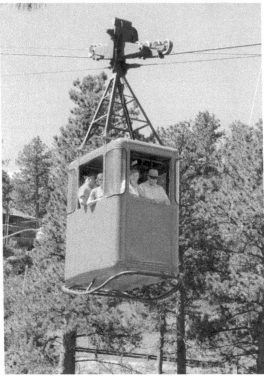

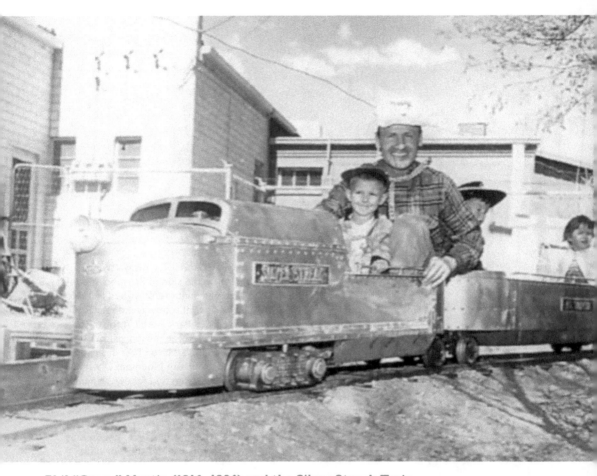

Phil "Casey" Martin (1916–1996) and the Silver Streak Train
The train whistle blew, and children gathered around as Phil "Casey" Martin strutted along the platform in his conductor's hat. Once the children were seated in the 17-inch-high passenger cars and Martin had collected their tickets, he put on his engineer's cap, blew the whistle, and climbed into the eight-horsepower Kohler gasoline engine for the trip around the quarter-mile track through Lollipop Land, past Humpty Dumpty and Red Riding Hood. As the train chugged down the 12-inch-wide track, Martin sang, "We're going on a trip away, away. A long, long trip we travel today. From Hatchamahatchee to Kalamazoo to Kankakee to Timbuktu." The train then stopped by Trout Haven, and Martin handed out fish food to the kids. Anyone who visited Estes Park during the summers from 1947 to 1972 remembers the Silver Streak train. Martin first operated his train on the north side of Elkhorn but, six years later, moved his track across the street next to the original Trout Haven. During the school year, Martin taught physical education at the Estes Park elementary school. Former Olympian Wendy Koenig Shuett recalled, "Phil allowed all of us total freedom to try gymnastics, rope climbing, track, soccer . . . During at least one winter, we were taken to Hidden Valley to ski one afternoon or day per week." Finally, after 25 years, Martin sold the Silver Streak train to Harvey and Marcella Coleman and began working as a summer ranger at Rocky Mountain National Park. Years later, kids who rode the train sent Martin invitations to their weddings. Martin sent them a railway ticket in return. (Courtesy of Estes Park Museum.)

"Crazy Ed" Kelsch (1940–2013)

The residents of Estes Park knew it was duck race day when "Crazy Ed" Kelsch shaved his winter beard. Often dressed in red, white, and blue and a NASCAR jacket, Kelsch walked the streets visiting the businesses and asking the merchants about family and employees. In the evenings, he checked store doors downtown to make sure they were locked. Kelsch bought locally and ate at a different restaurant every night of the week. A self-taught demolition expert for the town's Power and Light Department, Kelsch retired in the late 1980s. There are stories of him mooning the tourists, running down Elkhorn Avenue in a gorilla suit, scaring kids wearing a wolf's mask, and throwing fireworks into local bars. (Above left, courtesy and copyright of James Frank; above right, courtesy of Estes Park Museum; below, courtesy of Gerald Mayo.)

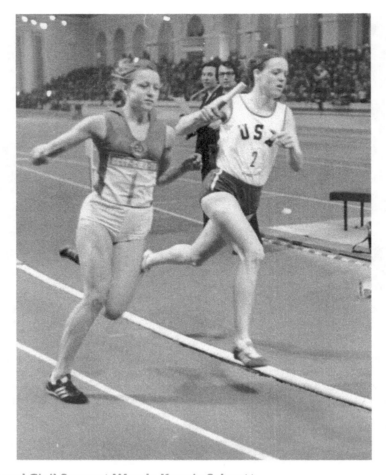

Olympian and Civil Servant Wendy Koenig Schuett

During her 16-year running career, Wendy Koenig Schuett appeared in *Sports Illustrated*, received three All-American honors, ran in the Olympic games twice (1972 and 1976), and set Colorado State University (CSU) records in the 800 meters (1:59.91) and 1,500 meters (4:21.80). Born in 1955, Wendy grew up in Big Elk Meadows and Estes Park. After she competed in the high jump at the Junior Olympics in Knoxville, Tennessee, her track career blossomed. She competed in indoor and outdoor events for the Amateur Athletic Union throughout the United States and Canada. Wendy won the 880-yard event at her first international meet in 1972 and later qualified for her first Olympics in Munich, West Germany. After enrolling at CSU, Wendy's running career took off, and in 1975, she won her first All-American award in the 800 meters and was named the winner of the Sportswomen of Colorado Award, an honor she also received in 1976 and 1977. More running titles followed, and she qualified for the Montreal Olympics in 1976. Wendy worked as hard in the classroom as she did on the track, becoming the first winner of CSU's Mencimer Memorial Award, given to its most outstanding female scholar-athlete. After her running career, Wendy continued to participate as a US track and field athlete representative and board member, Olympic Committee representative, and Olympic Committee board member. She opened her private audiology practice in Estes Park in 1989 and earned a doctor of audiology from Central Michigan University in 2004. She currently serves on the town board and has served on the Park Hospital Board. Wendy has a son, Jason, and two daughters, Kristin and Karin, both of whom were competitive swimmers at CSU. Today, she lives in Estes Park with her husband, Roger Schuett. Wendy is pictured wearing the white USA jersey. (Courtesy of Wendy Koenig Schuett.)

Mountain and Family Man Tim Mayhew (1962–2008)

Family and hunting were the most important things in Tim Mayhew's life, but he was not afraid to "work hard, work smart" as grounds superintendent for the Estes Park Fairgrounds. Wearing a worn straw hat with a feather in the band and drinking a cup of mud (coffee), Mayhew ran a tight ship. He referred to every employee as "Virgil" so he didn't have to remember names ("Virgette" for women). He was a native of Michigan, where he learned to hunt and fish (on prom night, he took his date coon hunting). Mayhew arrived in Colorado in the mid-1980s and began working for the town of Estes Park in 1986. He married his wife, Rita, in March 1988 and took responsibility for a wife and four children. "Those kids were his kids," Rita said. "He hit the ground running with being a father and a grandfather." But Mayhew could get a little ornery. He fired his shotgun in the air when his daughter Wendy said "I do" at her wedding. Mayhew was a devoted hunter who always filled his tag, whether it was for bear, elk, deer, moose, antelope, coyote, or bobcat. Once, while hunting bear, he positioned himself with his back to a cliff so the bear would not sneak up on him from behind. Suddenly, the bear rushed Mayhew, who threw down his bow and leapt off the cliff for the top of a nearby tree, where he stayed for hours until the bear wandered off. Mayhew liked his steaks cooked rare. "Just slap it on the ass and put it on the plate!" Afterward, he would rub his belly and announce, "I'm full as a tick." Every winter, Mayhew spent months helping build the floats for the Catch the Glow parade. When he died suddenly in June 2008, the town of Estes Park added a float called the Virgil Express and dedicated a statue in his honor at the Estes Park Fairgrounds. (Courtesy of Kris and Gary Hazelton.)

Rancher and Martial Artist Eric Adams

The spirit of ranching is kept alive in the Estes Valley thanks to people like Eric Adams, who managed MacGregor Ranch for 14 years and today is in charge of Crocker Ranch, a 1,500-acre, privately owned spread along Highway 36 on the approach to Estes Park. Living close to the land and watching the natural life cycles of plants and animals is what Adams wants for his wife, Stacey Scott, and son, Benjamin. He maintains the ranch's four homes, fixes the fence, feeds the horses, chases off trespassers, and repairs roads damaged in the 2013 flood. He introduced cattle to the ranch, making sure they are grass-fed and hormone free. Adams wants his son, Benjamin, to know that milk comes from cows, not Safeway. After graduating from the University of Alaska Fairbanks with a criminal justice degree, Adams returned to Estes Park and went to work at MacGregor Ranch, where he became executive director in 1995. During his years at MacGregor, he reintroduced beavers and constructed scientifically designed fences to exclude elk but allow other animals entry. The Black Angus cattle that grazed on the grass meadows were antibiotic-and-hormone-free. Adams oversaw the preservation of 11 historic buildings on the ranch, and the three-year project won two prizes from the Colorado State Historical Fund. He also stressed education, teaching visiting students about ranching practices of the 1800s. Adams credits his success in running MacGregor and Crocker Ranches to his extensive martial arts training. Not only do he and Stacey manage Crocker, but they own an International Karate Association dojo, Crossfit Estes Park, and, with his mother, Jo, the Chocolate Factory. Adams has advanced martial arts degrees in Gosoku-Ryu and Shudokan Karate, Yoshinkan Aikido, Kobudo (weapons), and Hojutsu. Adams is one rancher you do not want to mess with. He is pictured with his son Benjamin. (Courtesy of Emily Rogers.)

CHAPTER EIGHT

Mountain Strong

Many Estes Park locals wear "Mountain Strong" T-shirts. Tough people live in the mountains—tough people who realize disaster strikes even beautiful places. During the last five decades, the Estes Valley has suffered through floods and fires that have tested its heart and soul. Through it all, this mountain town has endured and thrived. When the Lawn Lake earthen dam breached in 1982, trash collector Stephen Gillette alerted the town and saved hundreds of lives. Still, floodwaters inundated downtown businesses. Mayor Harry Tregent, who had experience dealing with the Big Thompson Flood in 1976, helped create the Estes Park Urban Renewal Authority (EPURA) and approved the Estes Park Downtown Redevelopment Plan. EPURA executive director Art Anderson guided Estes Park's transformation through four streetscape projects, added parking lots, a beautiful riverwalk, and Confluence Park. High winds whipped fires on the western side of Estes Park in the hot, dry summer of 2012, destroying dozens of homes. Later that winter, winds fanned a fire in Rocky Mountain National Park that threatened the town and forced evacuations. In both instances, Scott Dorman and the Estes Park Volunteer Fire Department were on the spot to prevent the fires from spreading. New town administrator Frank Lancaster calmed the community with his clear-headed leadership. In the fall of 2013, the rains did not stop. Massive flooding overwhelmed the Estes Valley, as well as the northern Front Range. Again, Dorman and Lancaster sprang into action. After the flood, homeowners and businesses rebuilt, like Steve and Becky Childs had done in the nearby village of Glen Haven. Residents like Marsha and Ken Hobert held fundraisers to help people in need. Kris and Gary Hazelton designed a Mountain Strong logo and let people use it to raise money for others. People pulled together and helped each other. Mountain Strong—that is what Estes Park and the surrounding communities are all about.

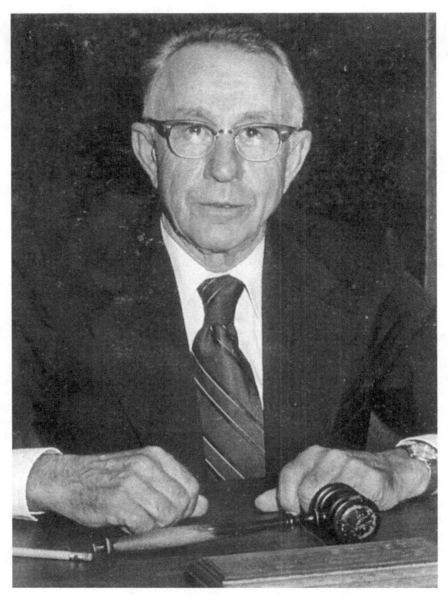

Mayor Harry Tregent (1914–1985)
On a summer day in 1982, Mayor Harry Tregent stood at the window in the Municipal Building and watched floodwaters rage down Estes Park's Elkhorn Avenue. Six years before, Tregent had led the town to recovery after the 1976 Big Thompson Flood, arguing with federal officials about the rebuilding of Highway 34. After the second flood, he spearheaded urban renewal that revitalized downtown. Tregent moved to Estes Park in 1930 and married wife Helen in 1936. After serving in the Navy in World War II, he went into the gas station business, forming a partnership with Joe Canfield to operate the Mobil station. He tossed his hat in the ring for the town board in 1964, serving for eight years before becoming mayor from 1972 to 1984. In addition, he served on the Estes Park Volunteer Fire Department for 25 years and the Estes Park Sanitation Board for 14 years. "For a man who used to pump gas," said a friend, "Harry was damned smart." (Courtesy of Estes Park Museum.)

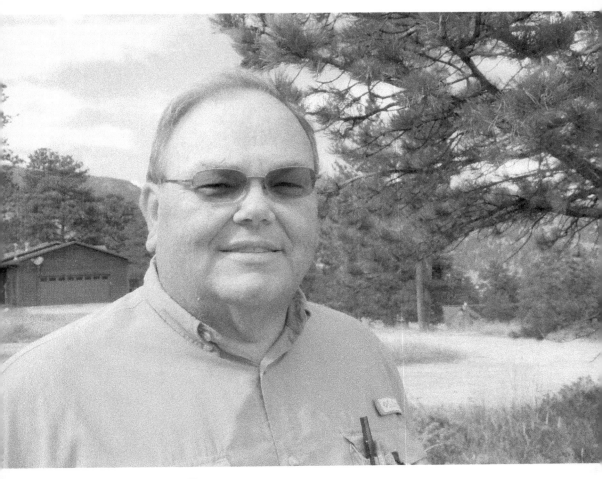

Stephen Gillette Warns Town

A little after 6:00 a.m. on the morning of July 15, 1982, Stephen Gillette drove his garbage truck into the Rocky Mountain National Park's Lawn Lake parking lot to empty trash. A noise like a crashing airplane drew Gillette's attention up the hill. "Here's this Ponderosa pine doing the loop de loop in the air. It was time to go!" Gillette said. He blocked the road with his truck to stop a curious tourist, ran for the emergency phone at the Lawn Lake Trailhead, and reported that the dam had broken. The amazing thing was that the phone worked at all. "That phone did not work before or after, but it worked for me," Gillette said. "I thanked God all the time. What would I have done next if I wasn't able to contact someone?" That morning, more than 300 million gallons surged out of the failed Lawn Lake Dam, turning Horseshoe Park into a lake, damaging roads, flooding 177 Estes Park businesses, and damaging 108 residences. At the height of the flood, Estes Park's downtown Elkhorn Avenue was under three to four feet of water. Gillette's cool head at the moment of crisis prevented countless deaths. During Gillette's life in Estes Park from 1981 to 2005, he served nine years on both the town board and school board. Now, he and his wife, Katherine, live in Berthoud and raise yaks on 36 acres. He is director of solid waste for Larimer County in Fort Collins. (Courtesy of Steve Mitchell.)

Art Anderson and the Transformation of Downtown

Today, one can stroll Estes Park's tree-shaded East Riverwalk along the Big Thompson River and enjoy the waterfall and sculptures at the George J. Hix Riverside Plaza. Benches and trees on Elkhorn Avenue offer rest and shade to shoppers. When Art Anderson and his family moved to Estes Park in 1971 and opened the Colorado Bookstore on Elkhorn Avenue, the river looked out upon dumpsters, dusty parking lots, and the back doors of businesses. The sun glared on narrow sidewalks of Elkhorn Avenue. But the devastating Lawn Lake Flood on July 15, 1982, prompted the town board to appoint seven members of the Estes Park Urban Renewal Authority and approve the Estes Park Downtown Redevelopment Plan. Art Anderson took the reigns as executive director of the tax increment–funded organization in November 1984 and helped transform the face of Estes Park through streetscape projects. Parking lots, the riverwalk, and Riverside Plaza (Confluence Park) were added. In addition, EPURA bought the knoll property, saving it from outlet stores, and redesigned the entrance to the Stanley Hotel. Anderson's job was a delicate political balancing act that involved convincing business owners to work together and allow their properties to be used for civic improvements. Some residents did not want to change a thing. Anderson retired in May 1999, and Wil Smith took over as executive director, extending the riverwalk plan west of Moraine Avenue, completing Performance Park, and constructing the south parking lot of the visitor center. Smith said the town's return on investment was double the $18 million spent on improvements since 1983. In a January 2010 mail-in election, 61 percent of voters supported dissolving EPURA, requiring voter approval for any future urban renewal authority. (Courtesy of *Solar Utilization News*.)

Steve and Becky Childs and the Glen Haven General Store

The flood of 2013 washed out the roads, bridges, and all nine businesses in the small village of Glen Haven. Only the Glen Haven General Store has reopened, thanks to the spirit, sweat, and hard work of owners Steve and Becky Childs. Some residents threw up their hands and left when they discovered the town was not going to receive money from government agencies to repair the $2 million in road damage, but it was not in Steve and Becky's nature to give up. "There's only one way this is going to get done—we're going to have to do it ourselves," Steve said. "It's one of the most amazing experiences to watch a group of people come together the way Glen Haven did." As the store began to come together, it offered a ray of hope to the rest of community, because it is such an integral part of everyone's life. First built in 1919, Becky Childs's family bought the store in 1976 after the Big Thompson Flood. They hired Steve to help rebuild, and the two hit it off. The store is known for its cinnamon rolls, delicious breads, cobblers, cookies, quilts, groceries, and 25¢ coffee. But then the 2013 flood hit, pushing town hall off its foundation and into the store. Steve and Becky spent the two days after the flood evacuating people across a river on a zip-line and building bridges large enough to get four-wheelers across so they could haul in supplies. After the Childs got the go-ahead from the federal government to rebuild, they restored the store from the inside out, fixing longstanding problems and making it look like it had always looked for regulars. Last season was the busiest in the store's history. Local groups are investigating how to rebuild the roads and the town hall, which will also house a museum. They are forming a new nonprofit called Glen Haven Flood Relief Inc. to relieve the fire department from flood relief duties. In the end, Steve and Becky want to continue the legacy of Glen Haven so their grandchildren can visit in the future. (Courtesy of Steve Mitchell.)

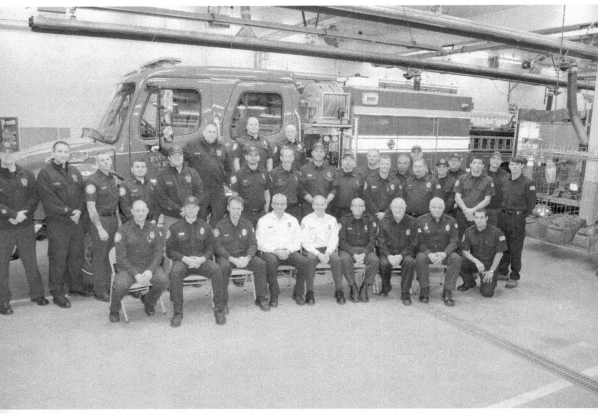

Fire Chief Scott Dorman and the Estes Park Volunteer Fire Department
The face of the Estes Park Volunteer Fire Department (EPVFD) has changed since Scott Dorman joined in 1983, when the department responded to only 80 calls. In 2014, the department responded to 650 calls. During his 32 years in the department, Dorman was a training officer, safety officer, EMT rescue diver, and assistant chief before becoming the town's first career chief in 1999. Dorman and three other volunteers were the first to become EMT certified in 1984 and, after a tragic river drowning, helped establish the Dive Rescue Team in 1989. As chief, Dorman guided the EPVFD as it struggled to become a Fire Protection District, finally accomplishing that goal in 2010 after three elections. The Fire Protection District passed a fire code in 2011. "We save a lot more lives and property through fire prevention than fire suppression," Dorman said. Though the department was tested by the Big Elk Fire in 2002 and the Park Theater Mall Fire in 2009, the EPVFD relied on countless hours of training during the summer of 2012 to fight the Woodland Heights Fire, which involved gusty winds fanning flames that destroyed more than 20 homes. Later that dry, windy winter, the Fern Lake Fire in Rocky Mountain National Park threatened Estes Park and caused evacuations. In the fall of 2013, torrential rains flooded Estes Park, forcing residents from their homes and cutting the mountain community off from the outside. During the first 72 hours, the EPVFD rescued 200 people. A resident of Estes Park since 1966, Dorman has been married to his wife, Dorothy "Dot" Dorman, since 1993. Together, they have six children and nine grandchildren. Dorman has an associate's degree in fire science technology from Aims Community College and a bachelor's degree in fire and emergency services administration from Colorado State University. Here, Dorman is one of the two men at center wearing a white shirt. He is on the right. (Courtesy of Gary Hazelton.)

Frank and Jill Lancaster—Calm in the Eye of the Storm

First there were the fires and the evacuations and the burned homes, and then there was the devastating 2013 flood. The calm in the eye of the storm was town administrator Frank Lancaster, who came into the job in May 2012. In every town meeting, he was composed, poised, and reassuring. Frank uses his keen sense of humor to poke fun at himself, embracing the well-meaning nickname "Disaster Lancaster." Mayor Bill Pinkham said it best: "What a blessing that Frank Lancaster joined us as town administrator in 2012. His vast experience made him uniquely qualified to work effectively with the incident command center and town board to oversee the flood recovery." A Colorado native whose grandfather farmed outside of Denver, Frank grew up in Wheat Ridge, was an Eagle Scout, and earned an undergraduate degree in landscape horticulture and a master of business administration in management at Colorado State University. He served as Larimer County natural resources director from December 1983 to June 1994 and Larimer County manager from June 1994 to May 2012.

His wife, Jill, has headed the Estes Park Nonprofit Resource Center since 2012 and spent the better part of a year coordinating flood relief as the Estes Park work site coordinator for the Disaster National Emergency Grant. Jill has more than 30 years experience working with nonprofits, including the YMCA, Association of Collegiate Conference and Events Directors International, and the Association of Fraternal Leadership and Values. Together, Frank and Jill have made an unbeatable team, which serves the town of Estes Park. (Courtesy of Frank and Jill Lancaster.)

Newspaper Publishers Kris and Gary Hazelton

When a rainbow appeared over Lake Estes, Kris Hazelton saw it as a sign from God that the Hazelton family was supposed to live in Estes Park. Kris and Gary's daughter Kylie (Hazelton) Romig was fighting leukemia, and life was too short not to follow their dreams. So, Kris and Gary Hazelton put their house on the market in Illinois and moved to Estes Park in 1999 with no prospects. They worked at the *Estes Park Trail-Gazette* and for the town of Estes Park before several town leaders urged them to start their own newspaper. But they were going to approach it differently—the newspaper would be 100 percent positive. Gary told the town's organizations that "we are here to tell your positive story." Gary and Kris are convinced that the power of positivity helped pull their daughter through her illness. Now, 15 years later, the *Estes Park News* is thriving because of the Hazelton's love for Estes Park residents. When the September 2013 flood devastated Estes Park, Gary and Kris designed a Mountain Strong logo and allowed anyone to use it in collaboration with a relief effort. Not only does the Hazeltons' free weekly newspaper sponsor countless nonprofit efforts in town, but Kris has been a past president and member of the Quota Club for 15 years. The Hazeltons were also instrumental in starting Elkfest and making it into one of the most popular festivals in Estes Park. Gary and Kris were awarded the Business Philanthropist of the Year Award in 2015. (Courtesy of Kris and Gary Hazelton.)

Marsha and Ken Hobert Raise Funds for Glen Haven

When floodwaters washed away roads, bridges, cabins, and town hall in the mountain village of Glen Haven during the fall of 2013, Marsha and Ken Hobert were stranded with their neighbors with no outside communication for four days. Once the waters receded, the community—individuals, church groups, businesses, and service clubs—pitched in to remove debris and begin to rebuild, not waiting for permission or instruction. Money was desperately needed, so every weekend, volunteers stood in the middle of the road with a fireman's boot, collecting a total of $6,700. As the one year anniversary of the flood approached, Marsha came up with the idea of the Mountain Rivers Jubilee to raise money for Glen Haven Flood Relief Inc. The well-attended event raised $51,000 to help rebuild Glen Haven. In addition, the community received money from the Northern Colorado Foundation and grants from Estes Park Rotary clubs and individuals. For more than 30 years, the Hoberts have owned Hobert Office Services Ltd., which includes services such as graphic design, photography, signs, banners, bookkeeping, digital copying, and printing. (Courtesy of Marsha and Ken Hobert.)

INDEX

Visit us at
arcadiapublishing.com

Printed in the USA
CPSIA information can be obtained
at www.ICGtesting.com
LVHW011443301023
762552LV00008B/108